GRAFF
COLOR MASTER

freestyle color techniques for **GRAFFITI** art

scape martinez

IMPACT
CINCINNATI, OHIO
impact-books.com

Contents

what you need

SURFACES

canvas

paper

walls

PAINTING TOOLS

acrylic paint

gel medium

gesso

latex paint

permanent marker

spray can caps

spray paint

OTHER SUPPLIES

latex gloves

gas mask

paintbrushes

painter's brown paper

painter's tape

rollers

water sprayer

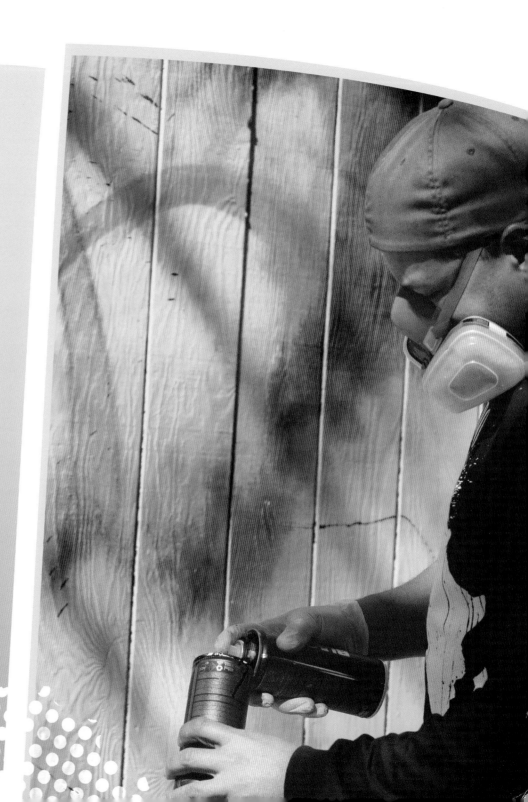

Introduction

From the very beginning I've always had a fascination with color. As a young child I was captivated by the bold colors found in nature. The yellows of sunflowers, the reds of roses, the blue of the sky, the deep blue of the night sky, how green that grass was. I wondered how to replicate those colors in my drawings and later how to replicate them in my paintings.

Even in my early days as a graffiti writer people would often comment, "Bro, you do your colors weird!" and "Why do you blend colors?" and "You're not supposed to blend!" I would respond, "Because I can!" I always had this innate fascination with color, where it is in the world and where it is in my art, how I use it in my art. It's a very intimate and subconscious thing. These days I don't really think about how to use color, I just go. It's very much automatic.

People See Color Before They See Anything Else

Some may wonder what is the rationale for this book, what is its purpose, why write it? There are tons of books about color already. This book is an extension of me. This book is unique because no one has explored the nature of color usage within the universe of urban street art, and no one has explored his or her own color styles within this urban art universe. This is unique, this is breakthrough.

I learned many years ago that when others were concerned with their lettering styles, I was concerned with my color styles. When others were flexing arrows, I was flexing pink. When others where concerned with constructing their letters, I was deconstructing my letters. I was deconstructing mine to let those beautiful colors flow out, and over time my fill-ins became my backgrounds and a whole new form of expression opened up for me.

I learned that, yes, people do see color before anything, and it impacts them in many ways. Their moods, their feelings and ultimately their emotional wellness comes through color, so

before people would wonder about "what it says," they began to comment on "how it made me feel." Bold use of color allowed me to communicate with people in a way that simple letter structure could not.

I learned more about skilled improvisation, I understood that my spray cans were instruments, my paintbrushes were instruments. Just like a musician, I learned to play them and play them well. My colors were sounds, making music in my mind, that I put on walls and canvas. I began to make color choices based on the immediate environment and my deeper inner feelings; everything else was sign painting to me. I began to go deeper with my color compositions. I began to paint in what I called my "Graffiti Style Invention Cycle"! Things became more complex and yet more melodic, and all in this universe that we call graffiti art, but steeped in abstract expressionist stylings. The doors flung open, and that is where this book comes from.

This book is not about how to do graffiti, but this *is* how I make art. These are my personal cave paintings. Trust and enjoy!

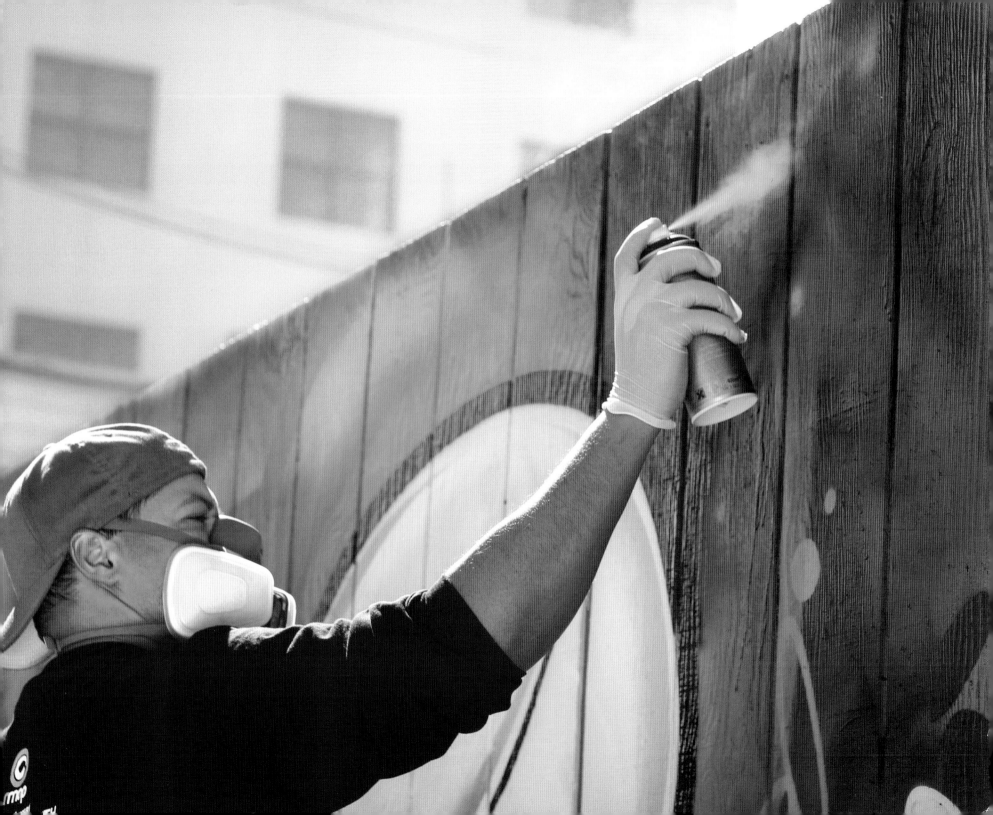

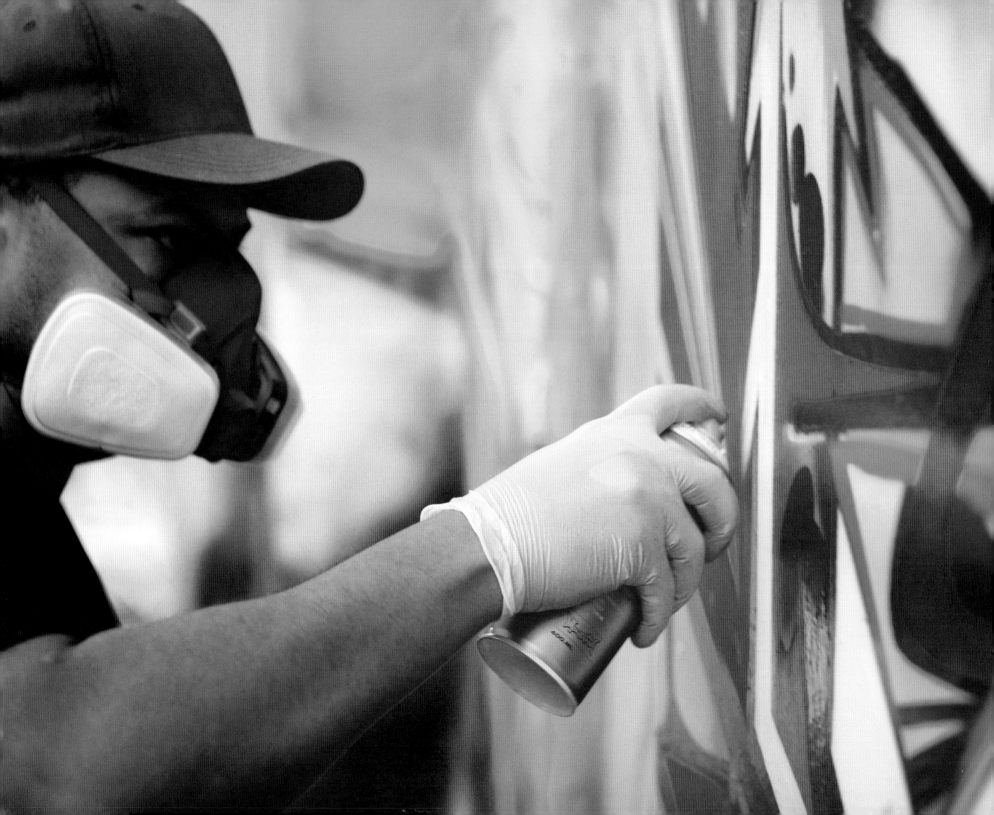

Color Basics

I frequently get asked the question, "What is the importance of color in the art of graffiti?" In my opinion, you can't have one without the other. Color is one of the ways we communicate as people. It crosses borders, languages and cultures. Color attracts attention, color commands power, color affects the senses and color informs. How many times have you seen a work of art and thought, *I don't know what it is, but I sure do like the colors*?

This chapter represents the building blocks of your color education. We'll dig into some color theory and technique, then apply the rules through spray paint, acrylic and digital exercises. Let's start with the primary and secondary colors and take off from there!

Paper and Canvas Art Supplies

When learning about color, even as it applies to street or graffiti art, it is important to understand and apply traditional concepts and supplies. To get the best color results, always work with the best resources. Experiment with traditional acrylics and oils because they have greater pigmentation than spray paint. Don't limit yourself—seek to understand and use as many different tools in your work as possible. Move beyond spray paint on walls and try out different mediums and surfaces, too. There are lots of rules and methods to using different supplies—you've got to learn them to break them!

Working on Paper: Paper comes in a variety of sizes, colors, textures and thicknesses (referred to as its *weight*). A paper's surface ranges from smooth to medium to rough. I prefer working on heavy multimedia or rough watercolor paper, the bigger the better. Always keep a sketchbook on hand for jotting down ideas and fleshing out your concepts.

Working on Canvas: Canvas is a heavy duty woven fabric that artists use to paint on, and something you can never take too seriously. I prefer cotton over linen canvas. It is available pre-stretched or rolled, raw or primed, and comes in various widths, weights and textures. I prefer a very large raw cotton canvas with a heavy tooth. It must be primed with layers of gesso beforehand, enabling me to prepare the surface exactly how I want it.

Brushes: Like pencils, there seems to be an endless variety of paintbrushes out there. I prefer wide, flat acrylic brushes with medium to long hair from 2- to 8-inches (5cm to 20cm) wide; they are good for covering large areas. For blending, I use filbert brushes that have flat, oval-shaped bristles. I prefer brushes with long handles as opposed to short, but experiment to see what works best for you!

All About Acrylic: Acrylics are my go-to paint and work great with spray paint. They dry fast, are high in pigment and can be mixed with water and other mediums to change the consistency of the paint. Acrylics are typically either fluid or heavy bodied. I prefer bold, undiluted acrylics in fluid form.

Mediums: Gels and mediums are additives used to make your acrylic paint behave a certain way. Mediums stretch the life of your paint and can be used to increase or decrease the paint's drying time, texture, gloss, transparency and much more. Experiment with various types of mediums to discover how you might use them in your work. I prefer matte medium to paint, heavy gel medium to blend and gloss medium to glaze.

THE IMPORTANCE OF SKETCHING

Sketching is crucial, especially concerning graffiti art. You must practice and doodle consistently—repetition is key! In the process of repetition, you learn certain flows and movements that work and that are unique to you. Repeat these expressions on different surfaces so you know what works where. Planning your piece is also important. Sketching allows you to open up and lay out your ideas, to place images and juxtapose them. I like to sketch with colored pencils only, no black or gray. Sketching is all about getting your ideas out, they never have to be perfect. Combine your letters with symbols and text and you will go far!

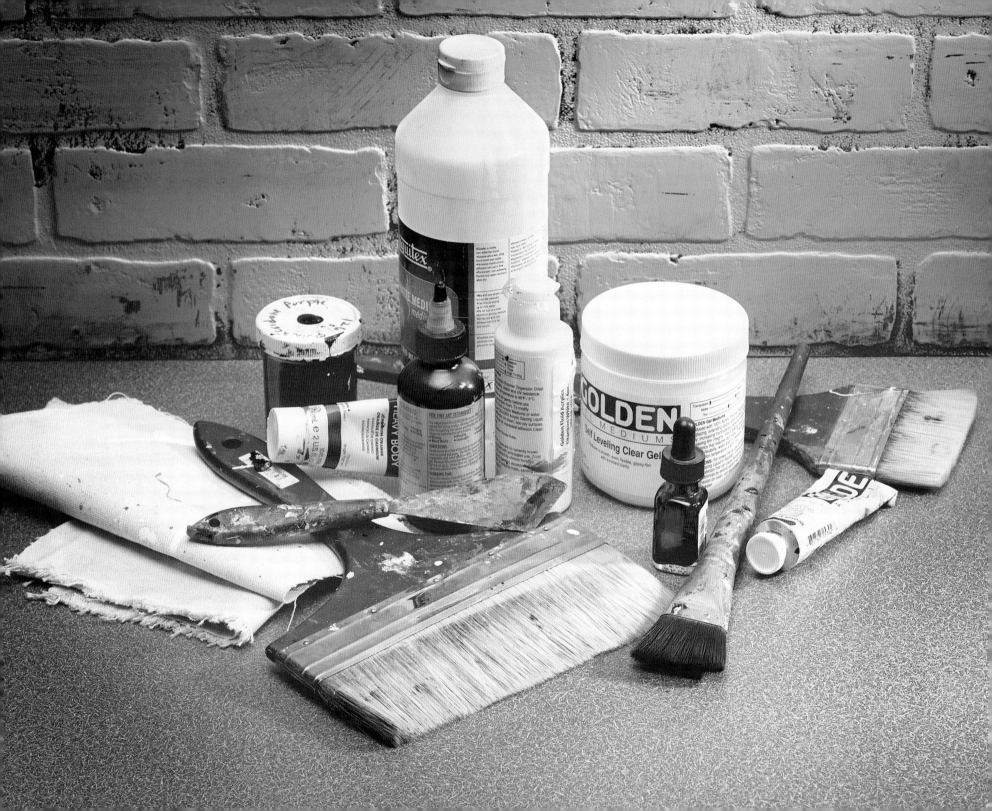

Street Art Supplies

When choosing street art supplies, always go with the best quality you can find and afford. Don't settle for less or you'll regret it later. Experiment to see what tools and paints work best for you and your work!

Spray Paint: The equivalent of the artist's ink or paint, spray paint is the graff artist's most important tool. Not all spray paint is the same; there is a difference between glossy, satin and matte finish spray paints. Different parts of the world manufacture paints to different standards, so experiment with as many different types as possible to be sure you make a good choice. Choose a paint that's bold, has a lot of color, sticks well to surfaces and covers surfaces well. Remember, the spray can is connected to the hand, and the hand is connected to the artist's heart, so I cannot overstress the importance of the quality of your paint. You will learn to express everything through the tip of the spray can.

Spray Can Caps: These are the equivalent of the artist's brushes. There are tons of caps out there, varying among the different types of paint. To start off with, be aware of four basic types with some variations depending on where you are and what's available.

★ fat caps

★ skinny caps

★ outline caps

★ fill-in caps

Practice with these for sharpness, evenness, resiliency and calligraphic style. Pack plenty of caps—more than you need (and take care of them).

Latex Gloves: Gloves protect the skin from paint. As you work your piece and change spray can tips, paint will begin to accumulate on your fingertips and hands. This can be problematic as it turns into a gooey mess, sometimes clogging tips and getting in the way. Also, depending on the type of paint, too much paint on exposed skin can be harmful down the road. It is best to play it safe. Bring a box of medical latex gloves and change them often.

Mask: To prevent inhaling fumes, use a legitimate gas mask—do not use a bandanna or dust mask! It may take a while to get used to working with one, but it will protect you from fumes and overspray getting into your nose and mouth. Many writers can talk poetically about how they never used masks back in the day. And many writers can say they wish they would have. Play safe, play longer.

Health Tips: When executing your work, use common sense. Follow all instructions to the detail on anything you use. Do not leave your spray paint in direct sunlight. Do not leave your spray paint in any area close to extreme heat or fire, heaters, etc. Take frequent breaks to rest your eyes, walk away, remove the gas mask and look at your work. Take a few deep breaths and continue your journey.

Discarding Materials: Do not leave anything at the site. If you must, bring extra bags to collect residuals: used latex gloves, broken or used spray can tips and, most importantly, empty spray cans. Even when you think they are empty, they are not. Over time, the paint will settle and someone will walk by, pick it up and maybe choose to destroy your piece. Take everything you brought with you and dispose of all your used materials properly. From prep to completion, leave nothing. Leave the space better than you found it, your art included.

Rollers: Choosing the right paint roller will save you time and energy while you work. Choose the widest roller that you are comfortable working with. Also investigate the *nap*, or length of the fibers on the rollers—smooth, medium and rough naps are available for various surfaces. The heavier the nap, the more paint the roller will hold, which is better for heavy-textured surfaces such as brick walls. I prefer a medium, general-purpose nap for smooth- to medium-textured surfaces.

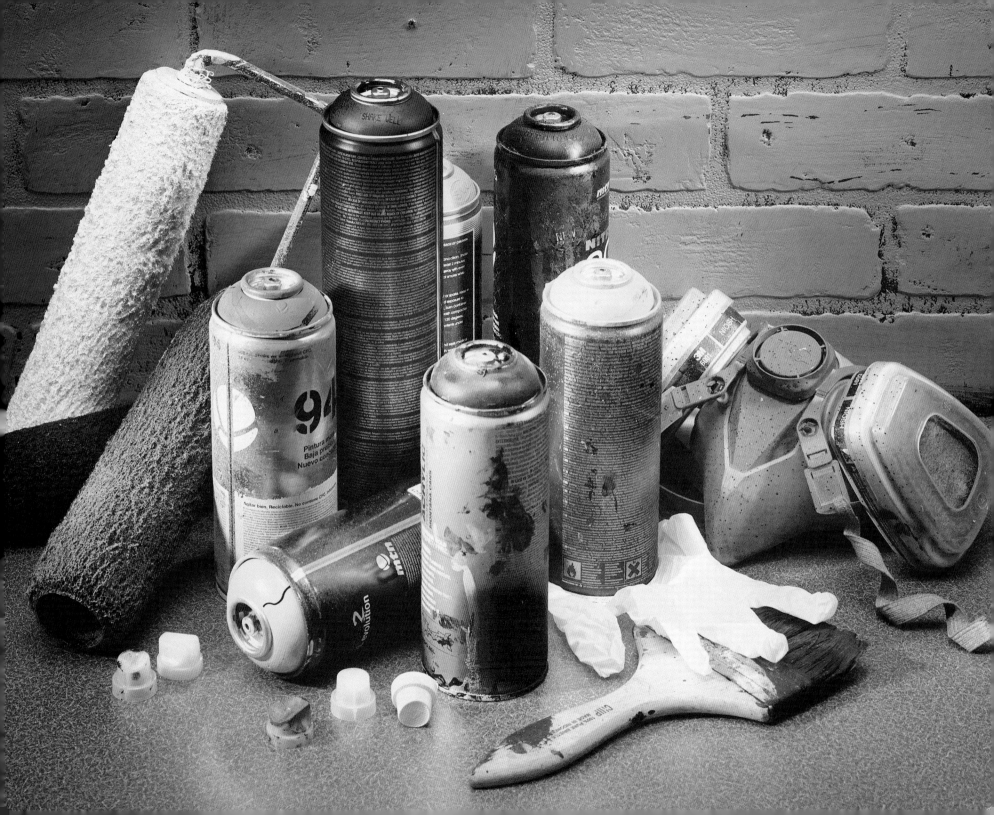

Instinct vs. Technique vs. Experience

After I've gathered my art supplies but before I begin painting, I make sure that the three pillars of my artmaking process are in check—*instinct*, *technique* and *experience*. Instinct is the energy and drive to create. Technique is understanding your tools and using them to the best of their capability. Experience is the road map of your creative successes and failures that have led you to this point. While I am forming my ideas, color schemes and letterforms, I am also keeping these three things in mind. Let's examine why these pillars are crucial to my artistic process.

Creative Instinct: What I'm speaking to here is that energy and drive to create. The act of creation, that fundamental human desire to make something that separates you from animals and machines. This is tied into curiosity and establishing your presence, that you are *here*. Add to this your instinct, that inclination for direction without having a road map. In a sense this is about your drive, your direction and your intuition being in tune with your creative self, where ideas abound and inspiration is within your reach. This is what you follow.

Artistic Technique: This is understanding, to great extent, the tools of your trade and their proper, and in some cases improper, use. For example, you should know the types of brushes to use for any given situation. You should also know the proper methods of applying paint, its properties and what paint to use for the vision you have. How long does it take to dry? Can I paint on slick surfaces? How do the mediums interact with each other? What are the dynamics of an aerosol spray can? Understanding the mechanics helps you when you learn techniques: layering, shading, glazing, etc. You can't create your work unless you understand the techniques. It's like driving a car—you actually have to know how to drive to get to where you want to go. You can't just step on the gas and hope to get there. It's all about technique!

Creative Experience: Experience is the road map to your creative process, knowing what works and what doesn't. This can be memories of successes that you have had in creating your art. Experience helps you tap and apply undiscovered areas in your sphere of creativity, the places you want to explore. Experience is like a creative navigation system, pointing you where you should go and steering you away from where you've already been. Strive for new artistic problems to solve, and keep in mind those you have already answered.

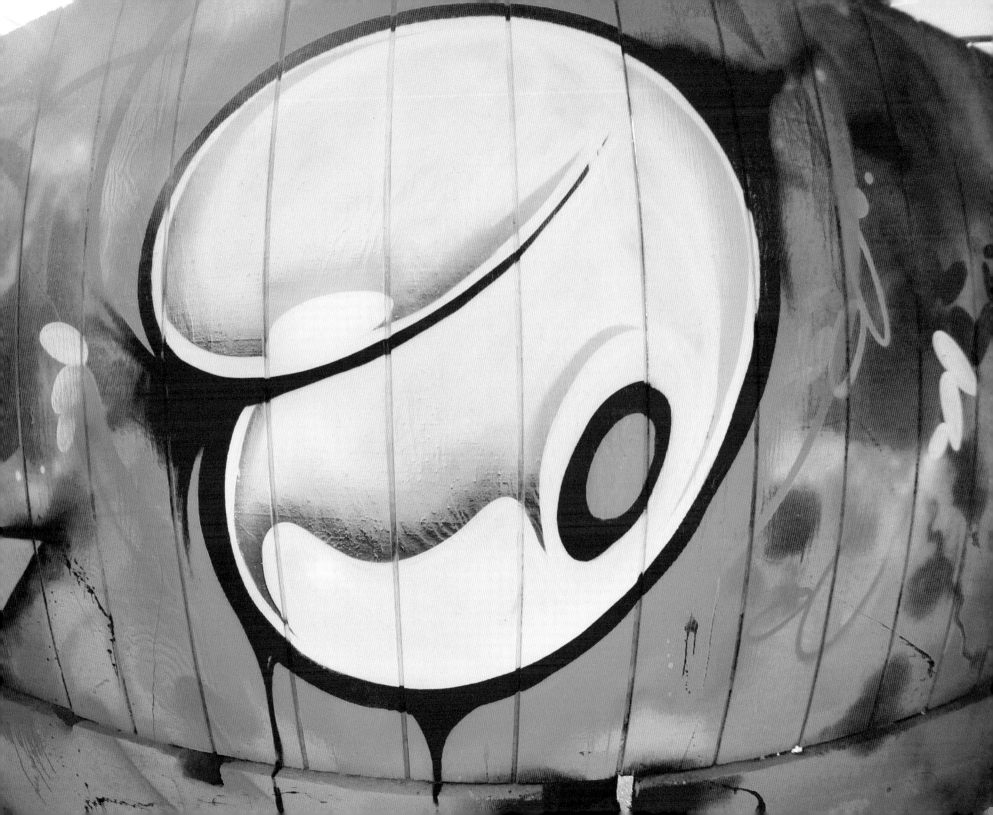

Spray Paint Mechanics

Spray paint technology has improved greatly since the inception of modern graff art, especially over the last decade. We've moved away from the wholly industrial product created for craft purposes to a fine art tool with millions of users around the world. In general, as spray paint formulas have improved, so has the art. Many technical aspects play a role in how we create dynamic art with spray paint such as drying time, the level of pigmentation, opacity and pressure, whether low or high.

Spray paint is a type of paint that comes in a sealed, pressurized container. It releases paint in a fine spray mist when pressing the tip (or valve). When working with spray paint, here are the most important elements to consider that affect your mark making:

* Color—the hue of each paint can
* Caps—fat, skinny, outline or fill-in, which vary the sharpness, evenness, resiliency or calligraphic styles of your application
* Coverage—how transparent or opaque the paint dries
* Drying time—varies depending on surface and weather conditions (e.g. humidity)
* Pressure—low pressure vs. high pressure
* Permanence—how long a pigment retains its original color
* Saturation—how pure or undiluted the pigment is
* Compatibility—how it interacts with other brands and types of paints
* Spray trail—the type of thumbprint or trail the paint makes, whether it's crisp on the edges or soft

Always test your paint before you use it to prevent blobs of paint from shooting onto your surface, and make sure that the proper caps are in play to prevent paint runs. Pack plenty of caps and take care of them while you are working.

Three elements of major importance working with spray paint are drying time, opacity and coverage. These properties allow you to layer your paints and cut into them to give your shapes, letters and forms crisp edges. This works best when the paint is dry and opaque. If your paint dries quickly, you don't have to wait to continue working. The faster the paint dries, the shorter the time between your creative thoughts and executing them! This can directly contribute to your creating really unique artwork. Whatever stands in the way between your thoughts and their execution needs to be lessened. So if that thing is drying time, seek out paint that dries faster. If your colors aren't bold enough, seek out more opaque colors.

fat cap skinny cap fill-in cap outline cap

SCAPE'S WORDS OF WISDOM

The fewer limitations you have with your spray paint, the fewer limitations you will have with your art, and the more elaborate and unique your work can be. Seek out what stands in your way and fix it!

Overlaying Colors

Each of these exercises was completed with spray paint on canvas. These days we can readily find specifically manufactured paints for graffiti artists: rich colors and hues, thicker or thin paint able to produce fat or thin coverage in various pressures. When experimenting with overlaying colors, take time to understand the tools that work and the tools that don't.

THE GO-OVER PRINCIPLE

A viewer's perception of a color depends on what other colors sit next to it. Here the red is the same in the center of each square, yet the eye perceives it differently. When surrounded by black it looks bigger, and when sitting on top of the green it vibrates. Understand the effects of all colors as they go over others.

HOT VS. COLD COLORS

Here we have juxtaposed hot and cold (or warm and cool) colors next to each other and added shades of black—red next to blue, orange/yellow next to purple, red/pink next to green. To practice, cut back and forth, carving out rectangular shapes. Be as random as possible, and shoot for a Piet Mondrian type of composition. Note which colors go well next to each other and which do not. Layer and overlap as much as you can.

CMYK OVERLAP

Here we've created a series of organic bubble shapes by overlapping some of my favorite colors, CMYK (cyan [blue], magenta [pink], yellow and key [black]). To practice, lay down some blue, go over it with the black, then add more blue over the black and continue to repeat with other colors, constantly rotating them out. Be as sharp and as precise as you can and note how the colors interact.

RANDOM COLOR APPLICATION

The goal of this exercise is to understand your paint's viscosity. Is it thick like honey or fluid like water? Thick paint will not drip as easily; know what works best for different techniques. Experiment with various caps and pressures, get messy and experiment a lot!

Color Theory

Color is something that many of us take for granted. It is an endlessly complex experience of light, time, space and sensory perception. Bright colors arrest the eyes and vibrate off the walls while desaturated colors recede into the background. All these things are experiential and equally experimental. It is vital to experiment. First, aim to understand single colors (hues) and combine them into pairs, then into threes and other sequences. Space them out in different ways to test their boundaries.

In your artwork, whether graffiti-based or abstract, always ask yourself, *How does my color scheme interact with my form*? Your form can be the actual letterforms, the form of the canvas or the form of the wall or physical space that will contain your color scheme.

Perception Is Key: Keep in mind how color is perceived by your audience. Remember that even though you think you've knocked it out of the park, color remains subjective and determined by context and the viewer. Experiment with context. Where is each color going? Which colors are they going to be paired with? Develop a sensitivity to color to help you make meaningful color choices. Gone are the days of haphazard color fills just because you have a bunch of scrap cans.

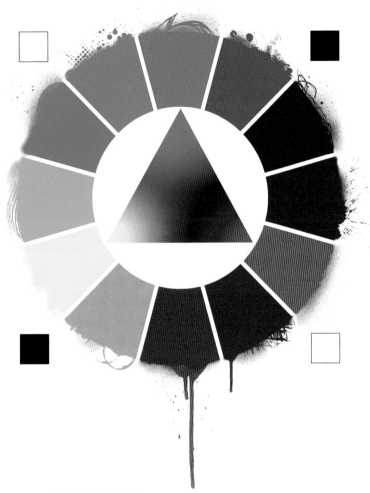

3 TYPES OF COLOR CHOICES

When selecting colors, there are generally three ways a color can convey meaning to your viewer:

1. **Visually**—The visual impact a color creates, e.g. how turquoise, pink and blue vibrate off each other

2. **Expressively**—The emotional impact of a color, such as the peacefulness of true blue, medium blue and light blue

3. **Symbolically**—Societal or cultural implications of the color, such as the colors of a country's flag

MY COLOR WHEEL

My standard color wheel is based on both CMYK and RGB color models and aims to channel the depth and dimension of color. I've selected hues for visual impact and light reflection rather than their pure hues. Refer to the relationships on this color wheel to make your work pop.

Moving clockwise, the top of the center triangle starts with cyan (blue), magenta (pink) and yellow, all laid over with key (black). The gradient and blending where each color meets show how all other colors are produced. For example, when cyan and yellow blend, green is created. The triangle points to corresponding colors on the surrounding wheel. When combined, they create *intermediate colors* and become more of a traditional color wheel. Colors that appear opposite of each other are *complements*. The black and white squares in the corners signal the presence of *tints* and *shades*—add black to create shades of a color and white to create tints.

Color Studies: Spray Paint

Experimenting with colors is the best way to learn how they interact with each other and ultimately with you and the audience. Three factors that play an important role in this are *value* (the lightness or darkness of a hue), *placement* (where the hue is going) and who is viewing it. Like musical notes, everyone hears music differently just as everyone sees color differently. The most important factor is you, the artist. How do you see color?

The following color exercises are designed to help you choose colors that work for you and your artwork, and they will ultimately push you to the next level as an artist. I use three main mediums to experiment with color: digital, acrylics and spray paint. Working on the computer not only gives you endless opportunities to experiment, but is great for experimenting with color theory. Acrylics give you great flexibility in creating colors you can actually use. And with spray paint, though you cannot mix colors in the traditional sense, it is helpful to work with the true color as it comes out of the can.

All of these experiments were completed in spray paint. Begin with a standard basecoat of either yellow, red, pink or black, and then overlay it with strips of colors from the same palette. What do you notice about the way the colors juxtapose? Which colors stand out or shift when they are beside another color? Which blues contain a bit of gray? Which red is boldest when next to a blue? Experiments like these, especially those using spray paint, allow you to understand what colors and brands work best when put together.

Over time you will be able to create your own set of guiding principles to create your art. Strive to create interactions of color that are unique to you as the artist, but always remember: red and yellow still make orange!

EXPERIMENT! THERE IS NO WRONG OR RIGHT!
Experiment with color on your own using acrylics, spray paint or by lining up swatches of colored paper. Remember that no two people see color the exact same way. There is no right or wrong way to use color. Practicing will help you make the most effective use of color in your work.

BRIGHT YELLOW BASECOAT
Yellow is the color of sunshine. Here we see how a yellow basecoat helps colors pop off the canvas. Notice how some yellows shift to orange when next to pure yellow. Greens are brighter when next to pure yellow. And turquoise shifts toward green.

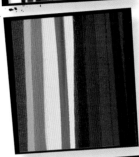

BRIGHT RED BASECOAT
Red is the color of fire. Note how blue pushes forward when alongside red. The turquoise pops right off the canvas, and the pink shifts closer to a near-red hue.

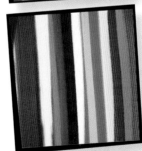

HOT PINK BASECOAT
Pink is the color of love. Here all the cool colors leap off the canvas, but the turquoises and blues shift depending on what is next to them, either leaning to green or blue.

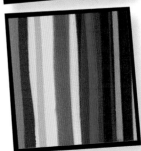

BLACK BASECOAT
Black is the color of night. Here the deeper and darker the black is, the bolder the colors will be that lie on top. Notice how the red and blue pop off the canvas and how the white appears to be a light gray.

17

Color Studies: Digital!

Computers are handy for creating color swatches and color combinations quickly to decide whether or not they work well enough to use with actual paint later on. No need to use real paint swatches, just arrange simple shapes of color next each other to see how colors react. Execute your best discoverires in real life for great results!

Find Unique Color Combinations With Random Swatches: This random series of colors has been arranged in precise squares. The idea is to be as random as possible to discover unique color combinations that you otherwise may not have consciously explored or combined. The key in this study is observing how the hues interact with each other. Ask yourself, *Where is there any color harmony? Where do they complement, if at all?*

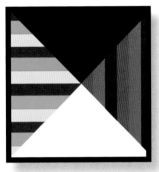

CREATE MOVEMENT WITH SHAPE AND COLOR

This digital study illustrates how the intersection of shape and color creates movement within a composition. Notice how your eye gravitates to the brighter left triangle of the exercise. It looks bigger but is the same size as the darker right triangle. The shapes lead the eye to the center where black and white meet.

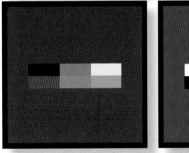

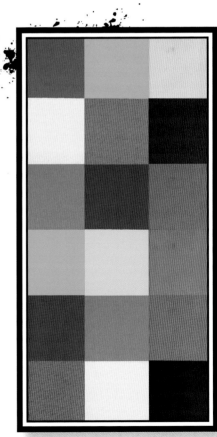

SELECT A DOMINANT BACKGROUND COLOR

The *dominant color* is the background color or the color of the largest area. Select your accent colors based on hue, saturation and intensity. Here the dominant colors are red and purple. Digitally mix and match accent colors that vibrate, pop or blend with that dominant background color. These colors can then be used to influence your artwork.

ALTER PERCEPTION OF SIZE WITH COLOR

In this study I've selected bold fields of color, yellow and magenta, for the backgrounds. In the center are three circles filled with hues that complement the background. Notice how the brightest colors pop and vibrate off the page, and appear larger in size than the others. Digitally experiment with different colors to change the perception of an object's size—this can apply favorably to the focal point of your composition.

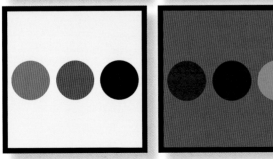

Color Studies: Acrylic

These studies were done with acrylics on canvas. Experiment with many mediums—markers, colored pencils, watercolor, oil paint—and change the color schemes to discover the most vivid composition to capture your audience's attention. Work with variations of light and dark hues to find the optimum contrast within your work. Color theory is very much a journey—over time you will understand what works best for you.

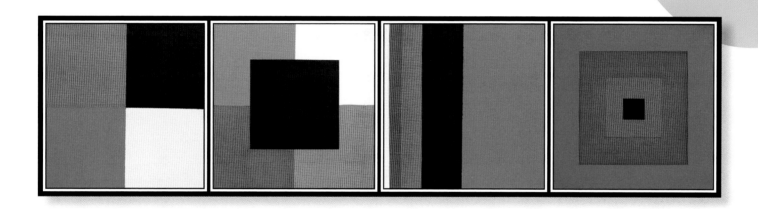

MAGENTA-BLACK-YELLOW-CYAN

This series of squares shows how a viewer's perception of color will change and travel, depending on what it is next to. Within a color scheme these squares are interchangeable. As you move the colors around or turn a square around, your eye will follow certain colors.

CYAN-YELLOW-MAGENTA-ORANGE-BLACK

Here are four colored squares with black floating in the middle. Depending on your point of view, you may see five squares, when in reality there is only one. The black in the center is so powerful, it sucks up a lot of light. It is the same size as the other spaces, but because of its position and hue it is overpowering.

YELLOW-ORANGE-MAGENTA-BLACK-CYAN

Here the color space is square, yet cyan occupies the full right half. Each color moving to the left of cyan is approximately half of the previous space. This composition blurs the line between what is space and what is a line. What colors would be best as an outline, a background or a fill-in? Which colors are hot or cold? Which colors vibrate and pop?

CYAN-ORANGE-MAGENTA-BLACK

In this study we use progressively smaller squares and place the respective hues within each space. Your eye notices the cyan first, the dominant color in the area, but also the black in the center. Notice how the eye perceives the colors as they contrast, complement and work together.

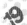

Saturated vs. Unsaturated

When working with color, understanding *saturated* and *unsaturated* hues is key to effective blending and contrasting. They will help you better communicate your ideas and make your work a bit more sophisticated. Saturated color is pure, undiluted color, or what I call "color right out of the can." It is the strength of the color, it is the chroma of the color and sometimes the colorfulness of the color. It is the pure, raw color without adding black or white.

Unsaturated color is a color that is dulled with shades of gray. Juxtaposing saturated and unsaturated colors will help push your graphic elements either forward or backward making things pop out or recede. A saturated color may appear stronger and brighter next to an unsaturated color, and vice versa.

Spray Paint vs. Acrylic: When working with fluid paint such as acrylics, understanding these ideas will help you blend your colors better and make your work pop. Working with spray paint is slightly different because you cannot blend colors in the same way. When working with paint straight from the can, select colors that are unsaturated and the overall concept still applies. Let's explore these ideas in action!

SATURATION 101
These are pure colors, undiluted and positioned in various forms. Saturated colors vibrate against each other and because of this may seem to expand. Notice red, the warmest tone, pushes forward, almost floating above the other colors. Study how saturated colors work together when deciding how to outline your forms.

UNSATURATION 101
Here we've added gray to saturated images, turning them unsaturated and dull. You may wonder, *What is the purpose of this? Don't we want our colors to be saturated all the time?* Not the case. Too much saturated color is difficult for the mind to process and may dilute your message. Balance is the key!

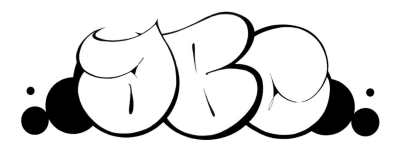

CLASSIC BLACK-AND-WHITE SKETCH
A basic bubble letter sketch, your ABCs if you will.

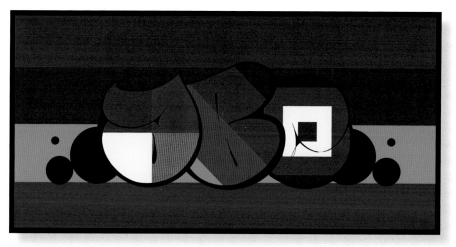

SATURATED BACKGROUND/SATURATED LETTERS
Take the black-and-white sketch and apply some color abstractions—bright, powerful patterns and colors. Let's see what happens when we switch the saturation.

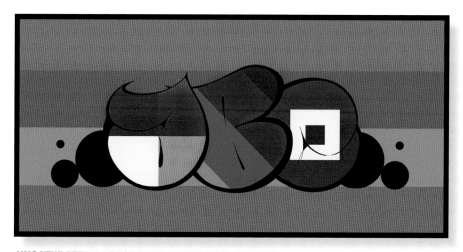

UNSATURATED BACKGROUND/SATURATED LETTERS
Here the letterforms are saturated on an unsaturated background. Notice how the letters are pushed forward and appear to float about the stripes. The work is less cluttered, not as busy, and the statement is bold.

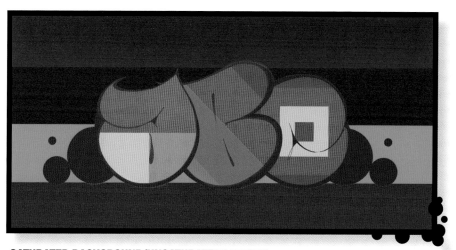

SATURATED BACKGROUND/UNSATURATED LETTERS
Here the background is saturated and the letters unsaturated. Here the ABCs seem out of place because your eye is drawn to the background, not the letterforms.

The Deeper Realms of Graffiti

In the beginning it was all about *getting up*—getting your work up as many places as possible. That slowly changed from getting up to staying up, to getting style, to having better style, to whatever manifests itself today. Now the heart of the manifestation is having a purpose behind that passion, that passion of getting up and getting style. But it's more than that. We must try to go deeper, add more meaning to our work, make it more purposeful, less accidental, with more deliberate colors, deliberate letters and deliberate movement.

Now it is all about getting to that next level, and you get there by pushing the limits of what you do, whether through style, technique, location or the message. Innovate and make it personal—it's less about the name and more about what you are saying. Think timelessly. Put your fingerprint on your work so anyone will know that you did it and exactly no one else did.

In this section we explore how to use color to tranform walls and outdoor public spaces. Think not about what your surface and space are, but what they can become. When you transform the walls you transform the space, atmosphere and, in the end, yourself!

23

Soul Station

Part of creating graffiti art deals with wordplay and achieving a cleverness with words and concepts. But sometimes, thinking out of the box and working without a sketch can be challenging. Try to embrace such challenges as opportunities to display new color ideas and techniques. One such challenge is creating a *site-specific* piece. Site-specific is when you create art that is designed and created to exist in a certain, particular place. It's when the artist, you, must take the location into account when planning out the piece to create a work that is meant to be there and not anywhere else.

In this demonstration we zero in on the word *soul*, which means the essence of a thing, in our case, the essence of graffiti art. As you prepare to freestyle, imagine the word as a human being. The letterforms are the body, and the colors and movement of the piece are its soul. While you focus on your concept, let your imagination flow. Think about the letters being animated, think of energy, flow your thoughts and emotion.

Let's begin!

FREESTYLE GRAFFITI
Freestyle graffiti is completed without a sketch by going with what you have, your bag of tricks. It's working in the moment, improvising and not having anything truly mapped out, maybe just a loose sketch in your mind. Freestyle has to have funk, it has to have rhythm and must have feeling. It can't be too tight, the letters too slick. Think open, loose and inviting. And of course, make it unique with your clever style!

PALETTE
Our full palette is made up of a spectrum of blues, yellows and pinks, all anchored with black and white.

OUTLINE PALETTE
Our outline palette consists of one color per letter. Since we are freestyling, we haven't decided which color will go with each letter just yet. We'll figure that out as we go along.

CANVAS
Our canvas is a wall primed with pure white primer. The edges have been taped off to give the work a clean, sticker-like look when completed. Peeling off the tape is also a great way to reveal the final work.

STEP 1: FIRST BACKGROUND

The first background is the foundation you will build upon, the first color you lay down, which is *not* the same as the buff color. It is the cloud, the haze, the atmosphere. In traditional graffiti steps, this would be the final stage but here it's our first. All of the piece's other colors and patterns will vibe off of this one, so it can't be a solid color.

1 In the spirit of working backward, begin from the edges and work inward. Rock the black and fade toward the center, adding a few tentacles of faded paint randomly throughout the work.

2 Now reach for the darker purple values in your palette. You want to work from dark to light, ultimately working toward the white, so go from black to deep purple to purple to lavender. Also bring in the deep burgundy and work that in a loose, blended fashion.

3 Begin to drop in ovals and expressive lines with black, reds and yellows. Notice how these colors help the composition begin to pop.

4 Your first background is finished when you have completely covered the wall space with color. Think of it like a traditional letter fill-in, only this time you're covering a complete wall with your expressions!

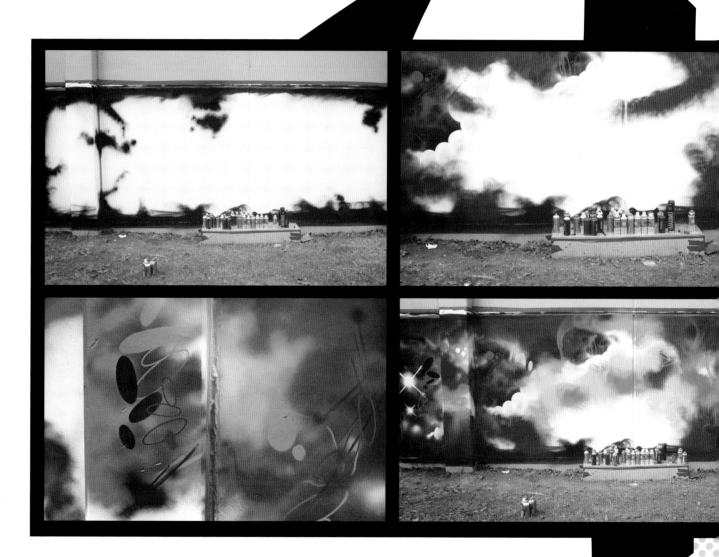

STEP 2: SECOND BACKGROUND

Your second background gets into the areas that people will actually be able to see. This is your second layer of color, which is directly based on what you did in the first background. This is a freestyle step—improvising on the spot!

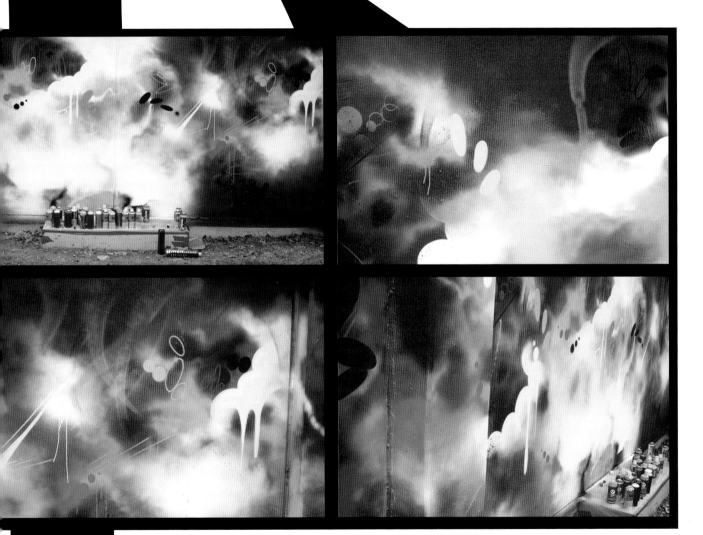

1 For the second background begin adding colorful textures and layers of expressions. Choose colors that contrast, in this case lime greens, yellows, pinks and black. Fold some yellow into the piece. Add clouds, lines and unique effects to create depth and rhythm.

2 Create activity and motion in your piece with flare effects created with fat caps. The hard angles of the clouds offset the gentle blending behind them. You want to be as expressive as possible, combining gentle, subtle color fades with bold, gestural strokes.

3 Create context and contrast with various drips, whether true drips from the spray paint or drawn-in drips. Play with the elements, be creative. Yes, your clouds can drip, why not?

4 Step away and look at the work from a distance. Walk around and look over the work, even looking at it from angles. How does it look? Notice the pillars of the wall on the right and left? Don't ignore them; work with them, which will make your work even more unique.

26

STEP 3: DETAILS

When you've maxxed out the spaces for your backgrounds, begin the details. This means you've exhausted all options for gradients, fades and atmosphere in the previous two steps. Here is when you begin to drop and cut in actual forms and shapes with greater detail, but not yet letters.

1 Begin to drop in details. Here the details consist of some hard lines, slices and focused arrows. For added expression, add paint spatters and cut into the atmosphere of the colors with purple and white.

2 Step back and review. Notice all the arrows and subliminal details? See where else you can add colors, shapes and expressive lines to bring attention to areas in the piece that need it. You want your eye to explore the entire surface of the work and to create depth through layers.

3 Step closer and continue. At this point you should be bouncing all over the wall, jumping from left to right and all points in between. Here you can see the arrows and bubbles coming out of the white. This is a good example of the *pulling concept*. Let's say you have two layered or blended colors, either light to dark or dark to light, and you can visibly tell which color lies on top. Pulling is when you bring the color from the back and sprinkle a little on top to add depth and excitement.

4 Back up and look at the work from different angles. If needed, embellish the pillars with some final drips, and lay some white highlights on top of the edges of the tape for additional contrast.

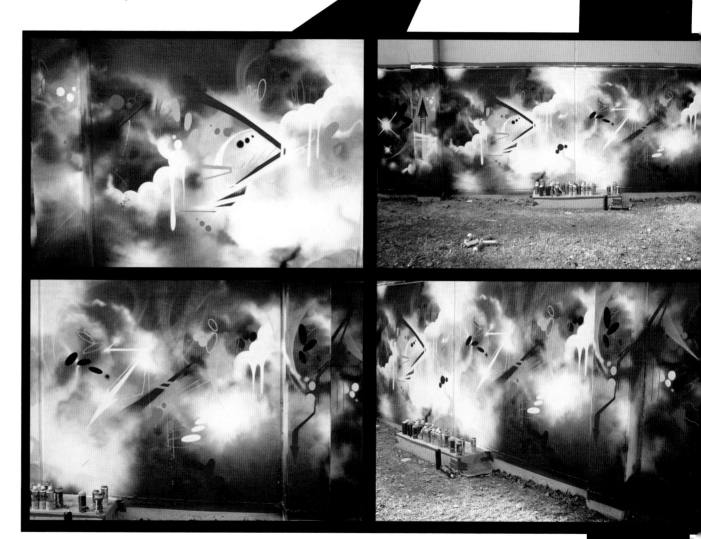

STEP 4: DROP IN AND PULL OUT THE LETTERS

After you have exhausted your ideas for details, drop in your letters. Think of your letters in terms of outlines and shape, not so much as tangible or solid. Choose colors that will contrast with that specific region of color, and bob and weave through the atmosphere of colors laid down. To pull out a letterform means that the shape you create is determined by the movement of color and the color itself, where the letter will sit within the piece.

1 After studying the color scheme of the piece, select a color for the letter **S**. I chose red because it pushes forward from the background. Take the red and strategically add it to the mess. When you are satisfied with your letterform, go in and clean it up a bit, slice it, cut it and make it expressive!

2 For the letter **O** reach for the white. White contrasts nicely with red, and the **S** in the previous step contains a good deal of white. Outline the letter with a globe-like shape and add a hard-edged stroke of true blue around it. To get a crispy edge, use a clean skinny cap on your can and get really close to the wall. Position the can slightly away from the center of the globe and work quickly and boldly. Notice that the blue reaches back to the **S** and drips out!

3 Using the same blue, rock the letter **U**. While the **O** comes across as solid, the **U** is transparent. Let the top portion of the letter fade out and allow the flare to be part of the outline. Let the outline of one letter be the glow on the other. Break the rules!

4 Use black for the letter **L**. Black is a powerful color and will act like an anchor, meshing well with the dark edges. Keep your hands tight and your movements crisp. Add some accents with orange and trace out the slices from the letter **U**. Be creative and think out of the box!

SCAPE'S WORDS OF WISDOM

No,
not that voice,

THIS VOICE, The Voice. Not the voice of your crew, not the voice of your peers, not the voice of the movement but the creative voice that is uniquely you. That voice will take you places; that is the voice that needs to be nourished and that is the voice that will take you to that special next level. Ideas and passion come together with drive and diligence to push you along and create art that was yearning to be created! But first, we need to identify that voice clearly.

Keeping It Real!

Frequently when you are going through your creative walk, whether it is in traditional art or street art, there are a ton of voices speaking at once. Those voices can be leftovers from other artists' literal voices, or they can be the visual information you see out in the streets. Everything from tags to pieces, throwies, banners, street signs, advertising. All of this creates a landscape that will influence your creative subconscious, and if you are not careful, it will begin to sculpt your creativity and you may begin to mirror it. Let them tag how they tag, piece how they want to piece, so long as you understand that you have the license to do it your way as well.

Paint because you want to paint, maybe even because you feel you need to paint. Get up because you need to, not for mainstream fame, but because it is an extension of you. Create from that place of original thought and style and to prove that you are unique. You will be surrounded by naysayers, especially if you are out to break the mold. Do not be deterred. Remember: You have something to say, and the entire world is out there waiting to hear and see you speak it.

WORDS TO CREATE BY

* It's a journey; your voice will take you from the black book to the walls to the canvas and on to the future.

* Find your voice, and once you find it, keep it!

* Focus, focus and don't lose your focus.

* It's not about being an artist or a graffiti writer, it's about expressing yourself.

DON'T JUST THINK OUTSIDE THE BOX, CREATE OUTSIDE THE BOX. A THOUGHT IS JUST A THOUGHT UNTIL YOU PUT SOME ACTION BEHIND IT.

STEP 5: COMPLETED PIECE AND DETAILS

In the last stage, go over your piece and add any final touches and quick fixes and clean up. When you drop in your messaging, think carefully about the placement. You don't want to clutter the piece, just add to it. Take a step back and soak it all in, taking your time on the final decisions. Your messaging is anything you want to communicate, an added snippet of commentary or observation.

1 The final piece reads **SOUL**. Add your signature tag and the messaging and you are almost finished! When the wall is dry, remove the tape to reveal the full extent of your work. Here it reads **SOUL STATION** in the upper left and **WHAT COLOR IZ YOUR SOUL** in the upper right. My tag and the year—**SCAPE 2013**—sits in the lower right.

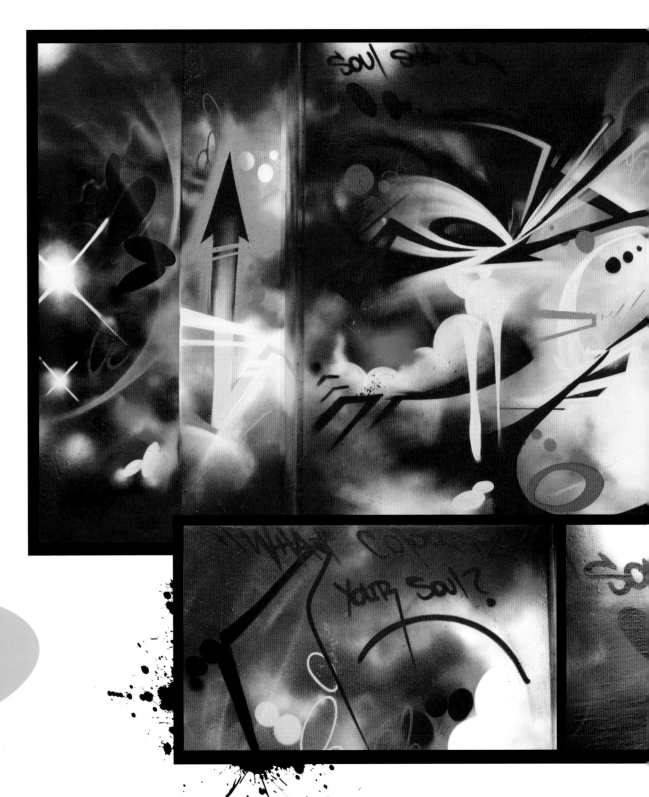

MAKE IT PERSONAL
Over time strive to make your work increasingly personal through your ideas and messaging, placement and color choices. The ultimate graffiti dwells between your ears, behind your eyes and smack in the middle of your mind.

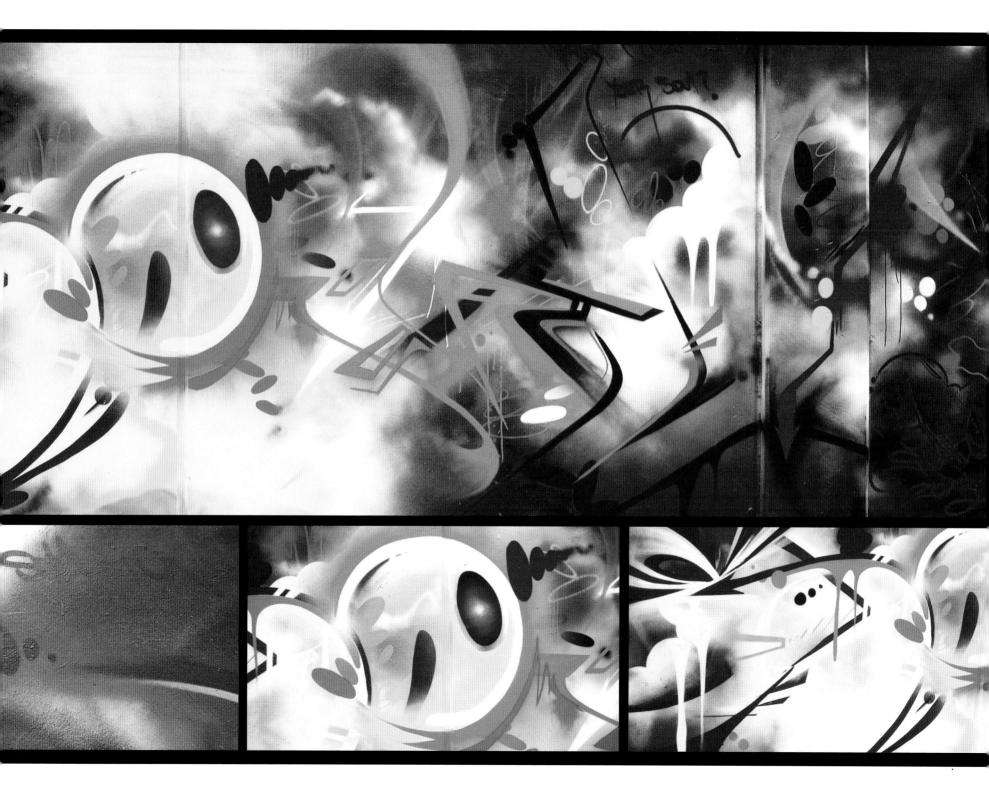

KNOW the Ledge

Can ya show whatcha know? The word *know* is a verb, as in to be aware of something through observation, inquiry or information; to have an understanding of something, in our case the know to go freestyle. When planning your concept, look closely at the word and its meaning, but also break it up and play with it. *Know* comes from the word *knowledge*, the accumulation of facts through observation and learning and respecting. Knowledge is the foundation; everything must be known in order to make it manifest. After some thought I came up with **"KNOW the Ledge"** for this demonstration. You need to know your style in order to draw it; you need to understand your tools and surroundings to make the work effective. To plan your colors and concept, look at all of your facts and information. What is the wall like? How will I make the letters look or feel? The **K** needs to be connected to the **N**, but in what style? What colors? What about my skills, are they up to par? Implicitly or explicitly, you need to know these things you need to have knowledge of these things, and you need to KNOW the Ledge. How far can you go with what you know?

Reflect and make manifest!

PALETTE
This is our palette, all the colors we have at our disposal. Start thinking of your fill-ins and how to make them pop off each other.

OUTLINE PALETTE
This is the outline palette I've selected for what I've planned in my head. Black, yellow, blue and red.

PRIMED WALL
The wall is primed a lovely lime green! The piece is taped off to give it a nice, crisp edge. The windows are taped over. They will work with the piece, not against it. Also, on the far right I sectioned off a slice of the lime green that will break away from the bulk of the art.

STEP 1: FIRST AND SECOND SKETCH

1 Grab a can of blue to begin the first sketch. In terms of color value, there isn't a huge difference between the blue and the green. That's perfectly fine for our first sketch. Lay down loose, initial lines and shapes for the letters and immediately negotiate around the pillars on the wall.

2 For the second sketch use orange to go over and tighten up the initial sketch. The orange lines are the ones you want to keep. Take your time and keep in mind how you want the letters to flow. In the close-up shot at right, notice the additional expressions, slices and bits that I added.

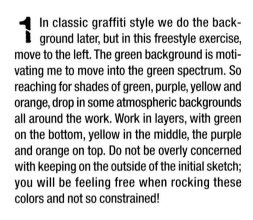

1 In classic graffiti style we do the background later, but in this freestyle exercise, move to the left. The green background is motivating me to move into the green spectrum. So reaching for shades of green, purple, yellow and orange, drop in some atmospheric backgrounds all around the work. Work in layers, with green on the bottom, yellow in the middle, the purple and orange on top. Do not be overly concerned with keeping on the outside of the initial sketch; you will be feeling free when rocking these colors and not so constrained!

2 In this close-up of the layered colors, take note of the darker hues on the edges and the lighter hues pushed toward the inside. The most vibrant orange shapes float on top to increase the depth of the piece.

3 Add yellow variations with a fat cap that sprays the paint out pretty wide. This allows you to see what is underneath, giving the work a transparent effect. Yellow is a good color for achieving this transparency as you work to transform the colors underneath.

STEP 3: ROCK YOUR FILL-INS

1 Go in an rock your hot colors! White, pink, red and orange. Remember the steps: blend, cut, slice and repeat. Blend your colors, fade the colors then cut into them, slice the colors up and repeat. Feel your way around the piece and letter structure by improvising and changing up your colors as you move along. The letters don't all need to be solid or continuous in tone. Look at the **O** and how it's more spherical than the other letters. If you feel like making a cut in a certain place, do it. If you feel like dropping a blend in a certain spot, do it. Feel it!

2 These close-ups show the cutting, slicing and layering of colors. Notice how the white blends in some areas, cuts into others and is also cut into. It lies on top of the pink and orange, then drips down. Remember to negotiate around the pillar, drop colors on it and make it work with the piece.

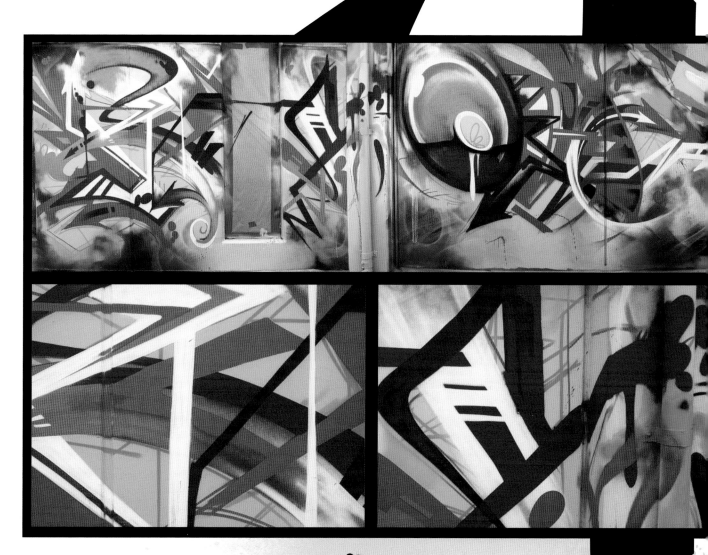

SCAPE'S WORDS OF WISDOM
Know the rules so you can break the rules!

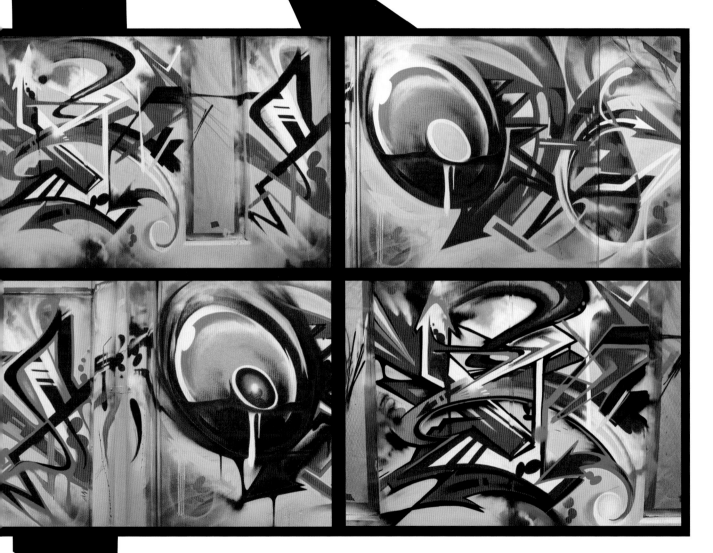

1 Drop in a glow using the yellow from step 3. Here you begin to cut out and fill in all that negative space in between and surrounding the letters. Work tightly in the center areas of the yellow and loosen up as you move outward. The farther away you go, the more expressive you can be with that yellow.

2 In this detail, study the arrows added around the **O**. Add whimsical lines and shapes, and drop in a few yellow bubbles to continue the feel of the work. Remember to build on the layers that you laid down in previous steps.

3 Take a break and rest your hands if you need to. This portion is crucial and can make or break your piece. After your hands and fingers are well rested, drop in the outline. Change the outline colors for each letter. The **K** gets black, the **N** gets blue, the **O** gets black and the **W** gets blue. You don't want the letters to stand apart from each other, but you do want them to interact, so add slivers of these colors into the letters that sit to the left and right.

4 In this detail notice how the black interacts with both the letter structure and the color pattern of the **K**. It has a lot of contrast but also needs a bit of cleaning up. Step away and look at what else is needed to make it all stand out even more.

STEP 5: ADD THE FINAL DETAILS

1 The final details are the little things that make all the difference. Pore over the piece and clean up any overspray, tighten loose lines and add highlights. Take your time and look at the work from various angles.

2 Add additional blue accents to the **K**, and shadows, dots and bubbles with black. Using yellow, add a few streaks, fades and highlights. The goal is to intrigue the viewer's eye into thinking the colors are interacting in ways that are really impossible.

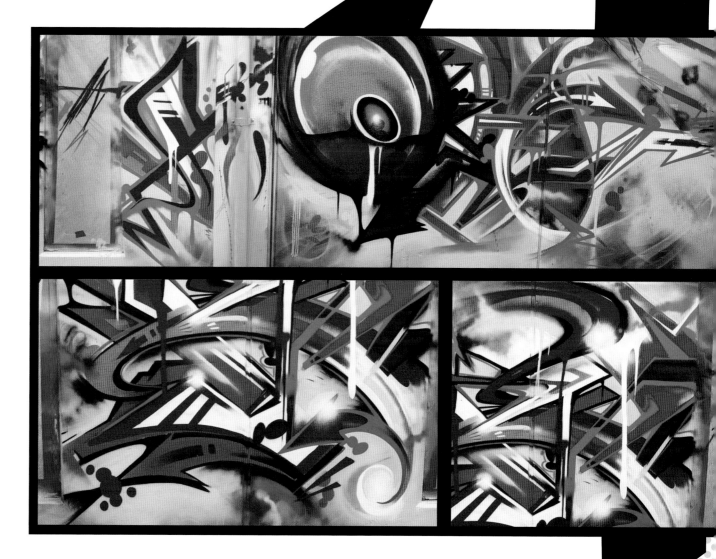

STEP 6: COMPLETED PIECE AND DETAILS

1 Remove the tape and paper from the windows to unveil the work, which reads **KNOW**. I added messaging on the bottom that reads **"Health, Wealth, Knowledge of Self, KNOW the Ledge."**

The detail shots show the layering and style components of the overall piece. The blue outlined arrow is connected only to the letter on its side, essentially coming out of the white swirl. In the second the trademark black ovals float on top, and the hot pink is sliced into the white. Third, it's all about those layers that you can see in the oval shape and using the black as a charcoal stick. In the final, you can see how taping off the work gives it that absurdly crisp edge and pulls it apart from the surrounding background. No time to rest, let's go to the next!

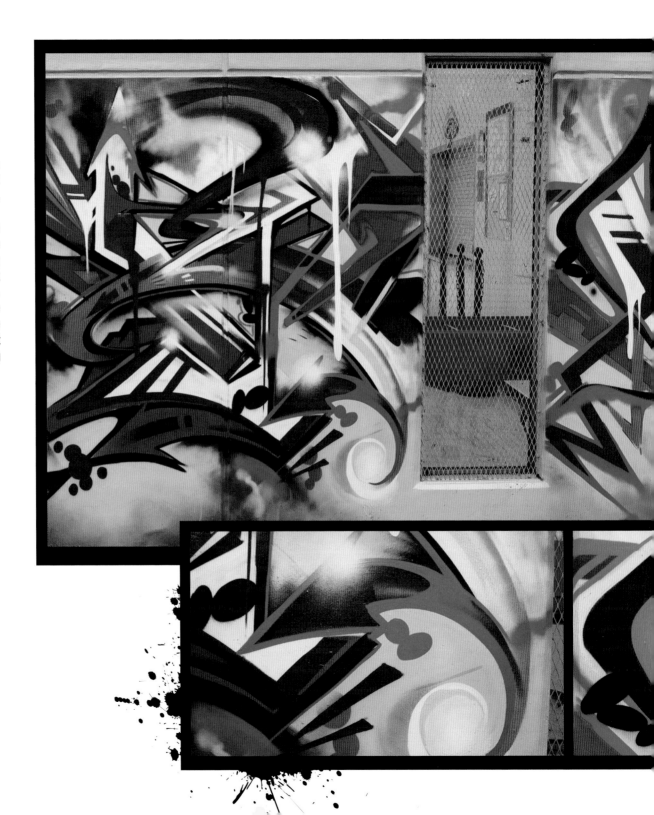

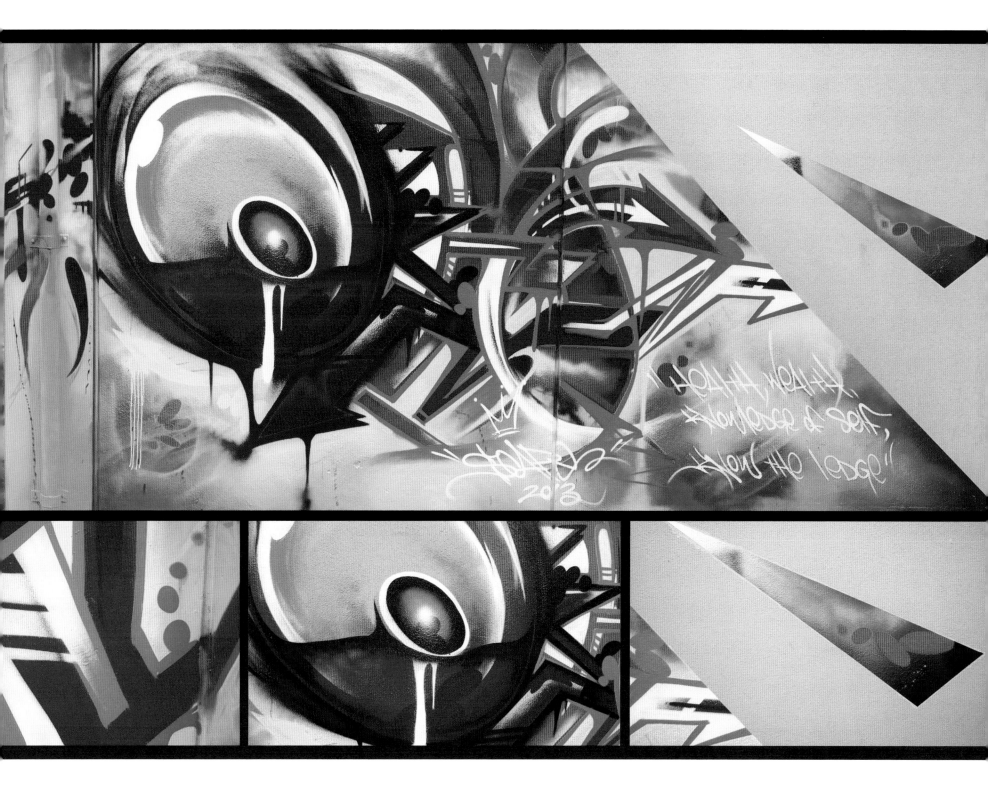

S.C.A.P.E.
A Color Experience

Back in the day, it was a prized concept to keep your color patterns consistent throughout the piece. If it was a light blue piece with a black outline, it needed to stay that way, beginning to end. If the idea was blue fades with purple bubbles, it was to be consistent throughout the work. That is not the case any longer! The first old truth to let go is the idea of the mandatory black outline. The second thing to go is the static fill-ins. With the new aesthetic you have the freedom to change your colors as you move along, changing your outline colors as well as your fill-ins, and making some areas more bold. Expanding your color rules is a freeing experience. Mix and match to challenge the sensibilities of both the viewer and yourself. Think of color as your subject, your form, your everything.

In this demonstration we take letter style to the next level and broaden our focus to include color. I urge you to take a creative risk and combine expressive letter styles with wild and intense color schemes that transform, roll and change throughout the piece. Each letter's color style will be unique to the previous. Put on some music and let's roll!

PALETTE
Our palette is made up of shades of green, pink, red and blue. Purple is a color that resides between blue and red; use that knowledge to choose your colors.

CANVAS
Our canvas is a nice buffed purple. Notice how the wall is taped off, including the angle on the left. Strive to create a composition that makes your work unique. Here it will interact well with the piece next to it.

SKETCH
Here is our black-and-white line sketch.

STEP 1: FIRST BACKGROUND AND DETAILS

1 Drop in some dark colors to create the first layer. Work in blacks, deep blues and purples, fading from the edges into the piece. Go back with black and fade dark to light.

2 Check the edges of your work. It's important to make your edges opaque and to spread the color fades throughout the piece. Step back and review the piece from various angles.

3 Add various expressions to the work with color splashes, drips, fades and flare effects. Reach for yellows, light blues and add a splash of red. Repeat over and over to build your textures and layers.

4 Back up and survey the work. As you develop the piece, remember that it is a process. Be fearless with bold strokes. Move color across the surface of the wall with reckless abandon.

41

1 Reach for the pink and begin to sketch in your letters. Don't worry about being tight with your lines, keep it loose! You want to capture the idea from the sketch rather than try to be perfect.

2 Look at the piece from the left and right. Does it look good? Does the lettering fit properly into the taped-off areas? Don't worry about what you may or may not be painting over; it's all a part of the method.

3 View your work right to left and evaluate how it flows through the separate taped-off areas. The artwork should move through them in one flowing piece.

SCAPE'S WORDS OF WISDOM

Let's put on our philosophical hats and improve our artistic vocabulary. *Visual semiotics* is the analysis and study of visual signs. In our society we are surrounded in our external environment by all sorts of visual information. This information can take the shape of symbols, images, signs and now tags and graffiti/street art.

As humans we have always tried to make sense of this, whether consciously or unconsciously, interpreting it as communication. Think of the meaning of all these images or signs as the central interaction between the message and the audience. A fresh tag may have a certain meaning when presented to a fellow graffiti artist but have an altogether different meaning to other passersby.

Signs, Symbols, Colors and Patterns

Study and change the placement of symbols, colors and patterns in your work to create additional meaning. This is how a tag becomes more than just a tag and a piece becomes more than just a piece. Think of your work and what or how you are trying to communicate. Break down and study this visual communication. Think of how you wish to place your art among all the visual information presently out there in the world. Graffiti is rife with signs and symbols. Aim to include analogy, metaphor, symbolism, signification and other heavily coded communication in your work. Ask yourself:

★ What is the relation between my visual imagery and the things it refers to?

★ Does my visual imagery have relation to other signs in the environment?

★ What effects does my imagery have on the audience who sees it?

The Methodology of Rhetoric

Rhetoric is the use of language to persuade or affect your audience. It is how we interpret the aesthetic meaning of a work. In graffiti/street art this can be difficult because the traditional "art speak" doesn't absolutely exist yet though we can begin the dialogue as to what makes a visual art piece good or not so good, as subjective as that can be. As you work to improve yourself as an artist, begin an aesthetical conversation about your work in the context of where it is, how it is, what it means and so on.

ANALYZE YOUR WORK AND OTHERS' AS MORE THAN JUST A TAG. NEXT TIME YOU SEE SOME STUNNING ART IN THE STREET ASK YOURSELF, "JUST WHERE DO I FIT IN?"

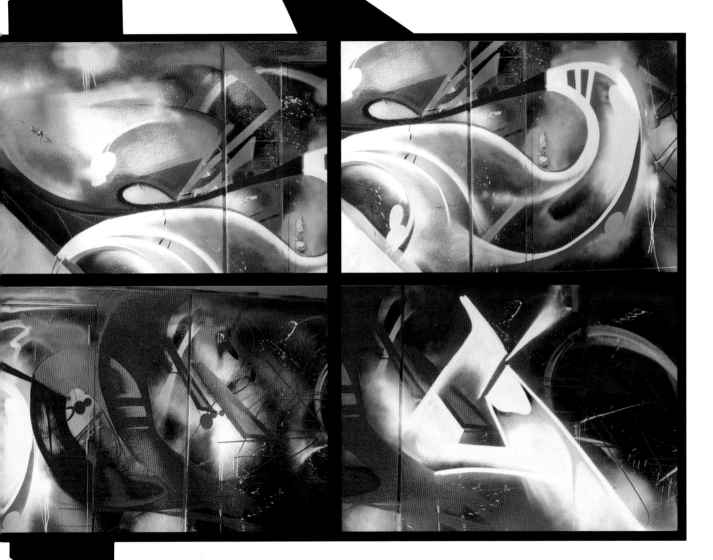

1 Drop in the color for the letters, starting with the **S** that is broken up into two pieces. Use shades of blue for the top portions and white into lavender for the lower curve. Continue to work with the colors underneath, in this case blending the blue out of the top of the letter into the background.

2 Switch it up! Reach for pinks and oranges and proceed to fill in the **C**. Fade out some areas of the letter at the top and lower right side. Go with the flow of the letterform and follow with paint.

3 Drop in black, white and gray for the **A**. Add some bright white to the mix as well. Your color choices should not be random. They should work within the context of the letterform itself and with the colors of the letter that precedes it. White works well with the pinks and oranges of the **C**. Create some metallic effects to play with the viewer's eye.

STEP 4: DROP IN COLORS TO THE P AND E

1 Choose bright greens for the **P**. Look at the letter structures and make the top portion of the **P** green and the back portion yellow. To make it interesting, add some true blue to the yellow and slice some hot pink into the green. These little bits of color add a lot of life to the letter and make it stand out.

2 Note that the **E** and some of the other letters are broken up into two sections. Fill in the top with black, burgundy and red, drifting into orange. The lower portion is light blue. Remember to push that light blue right off into the areas on the left.

3 Now walk back, way back, and view your work. Try to remember what it was like when your fill-ins were all one scheme and when your outlines were all one color. Contemplate the changes of just a few different steps.

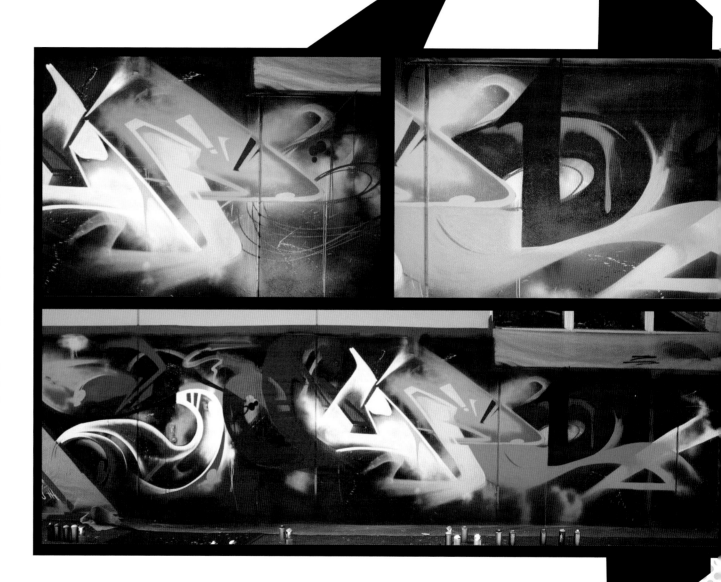

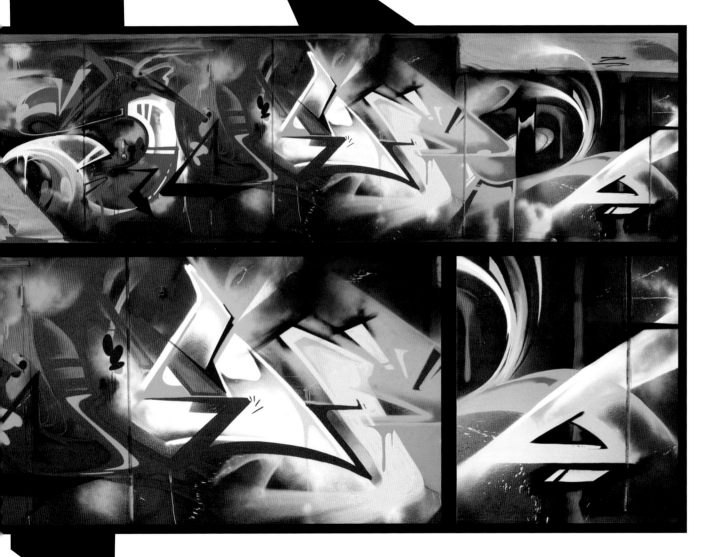

1 Up to this point we have been working really loose; now it's time to tighten things up! Beef up the edges of the letters with white and black, and bring in some arrows, shadow accents and dots. Add more cuts and color slices to discern the letterforms and make them stand out from each other.

2 In the close-ups, note the direction your eye is pulled. Add details, shadow effects, drop shadows and other details you like. Remember that black adds drama to the piece, so bring it!

46

STEP 6: OUTLINE THE LETTERS AND ADD MORE DETAILS

1 Vary your outlines with white on the top portion of the **S** and red for the lower portion. Use your imagination and have some fun! Allow some of the outlines of the letters to flow into the other letters or fade into the background. Some of the outlines can break off and fade out or even fold back over into the letter. Experiment! Use your hand techniques to create blazing flare effects that go with the outlines. By working from your wrists with a curling, hooking motion, you can create blazing flare effects that go with the outlines.

2 Add details that can be messages and float in extra color segments. Add some shines and be selective and deliberate with your bits and expressions. Remember to add your tag!

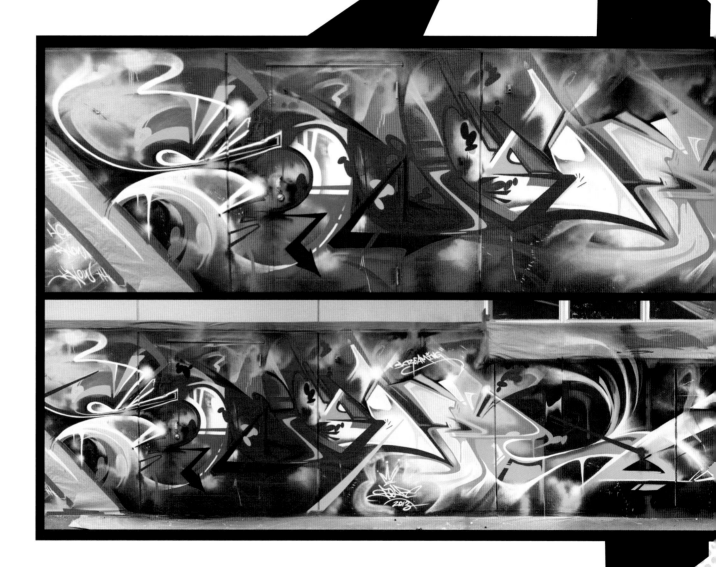

47

STEP 7: COMPLETED PIECE AND DETAILS

1 Carefully remove the tape and paper from around the piece. Step back, clap your hands and take some pics! Observe all the nuances and expressions throughout the piece. Take mental notes and get ready for the next one!

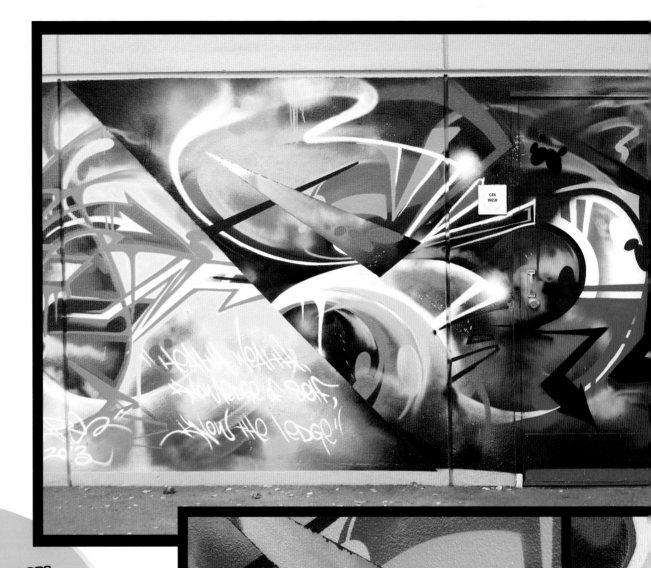

TIPS FOR TRANSFORMING YOUR COLORS

Nothing transforms us like color. Keep these points in mind as you plan and execute your work:

* Coordinate your colors; don't be utterly random.
* Keep your techniques in line with your color choices.
* Know the rules so you can break the rules.
* Juxtapose your colors with your styles and techniques.

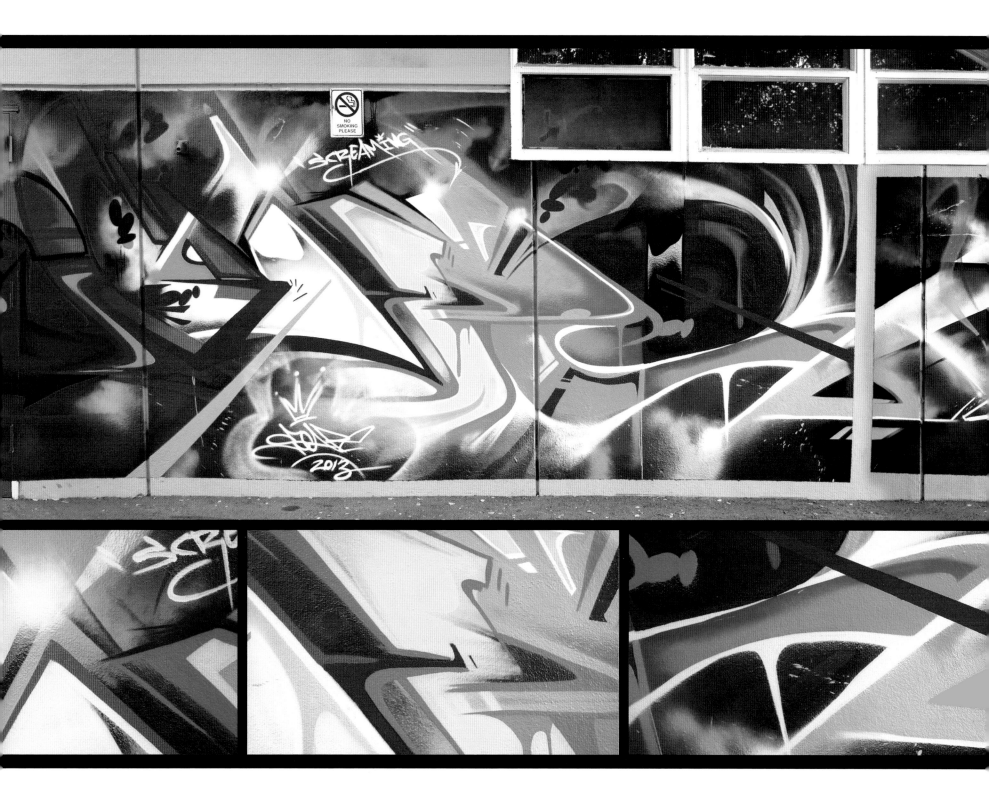

E.P.A.C.S. ≠ E.P.A.X.

Graff art is as much about wordplay as it is about colors and letter styles. Have you ever noticed how some of the graffiti artists you admire use language? They twist words and reinvent their meanings, sometimes using multiple meanings of the same word to help push the message along. A common practice is to replace letters, for example replacing a *Z* with an *S—writerz* instead of *writers*, and so on. Playing with the phonetics of a word is also common, illustrating how a word sounds versus how it is spelled out, for example *phat* instead of *fat*. A third practice is spelling a tag with missing letters, for example *SCP* instead of *SCAPE*.

This constant reinvention of letters, words and phrases is common in graffiti, and it's in this spirit that we approach this piece. Take the word of the previous demo, *SCAPE*, and flip it backward to get *EPACS*. Listen to how it sounds when the word leaves your lips. Manipulate the word based on phonetics. Recognize that the *ACS* makes an *X* sound and replace the *CS* with an *X* to create **EPAX**. Now that we have our concept, let's begin!

COLOR INSPIRATION
Decide what your color palette will be for a piece and stick to it for your background layers and letterforms. Then reach for contrasting colors and deeper hues to make the base colors stand out.

PALETTE
Our palette is made up of turquoises, greens, yellows and a slew of bright pinks. These colors will go great together to create a lively and festive work.

PRIMED WALL
Our wall is buffed and primed with lime green, which will really help our piece stand out. It is a grooved, wooden wall with a concrete base. It is heavily textured, which is great for holding paint. Remember to tape off the edges for a crisp look that will separate the work from its surroundings.

SKETCH
Begin with a simple line art sketch that we can elaborate and improvise as we go along. The fat **A** adds flavor and helps change things up.

STEP 1: FIRST BACKGROUND

1 For the first background, create a densely layered composition with movement, flow and layers using all the colors of your palette. Remember to add black along the edges to add a sense of depth. Proceed to add dots and cloud formations using your knowledge of color and spray techniques. Aim to gradually build layers and textures—this is your first pass.

2 This is your second pass. Go through and add another level of colors, this time focusing on forms and shapes including black and white. These random bits and slices should promote eye movement. The viewer's eye should bounce around the surface of the walls, taking all the visual information in. Add darker values into the work as accents.

3 Notice the layering? The yellow is beneath the turquoise that is beneath the pink, and yet the yellow comes back up and over the pink. This, as well as the black dots floating on top, helps to create depth and feeling in the work.

4 In this close-up of the right side of the piece, white is sliced into the bright pink. In this stage, overlay your colors repeatedly to build up the layers.

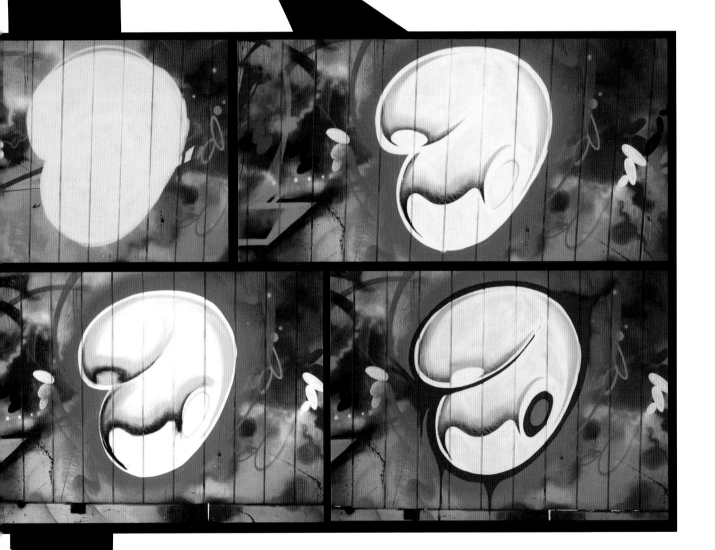

1 Drop in a bubble-styled letter **A** with white. At this stage it's okay that the white isn't truly opaque because we are going to continue to build upon it.

2 Give the letter a metallic, globular feel with a layer of gray and black. The gray goes in first, then the black. Next cut out the shape of the letter with white and tighten up all the overspray. Gently fade in some white over the black and gray to soften it.

3 Using turquoise, make the letter a bit more oval and egg-shaped by shaving color off the top and edges. You also may want to tweak the top part of the letter to reflect the sketch better.

4 Drop in a thick red outline around the letter, separating it from the rest of the piece. The red and turquoise clash, which is a good thing. We want it crispy! Drop in a few fades and drips, then move on to the next letter!

STEP 3: DROP IN THE LETTER E

1 Drop in the letter **E** and make it backward. This is a design choice that allows us to play with the negative space. Come in with true blue to draw the letter's shape; keep your hand steady and your lines crisp!

2 Reach for your yellows and pinks and do a little bit of cutting up. Instead of traditional shadows and highlights, use these colors to make the blue pop. Aim to accentuate the letter structure, but be careful not to go over too much of the background colors because they are now part of the letter's fill.

3 This close-up shows how the black is worked in. Black is a very strong color and brings lots of drama to a piece. Use it sparingly to bring attention to only certain parts of the work. Here black is used in the lower echelons of the letter and the shadows and fades of the left side of the composition.

GRAFF PHONETICS

Take all the liberties you want when it comes to wordplay and letter dynamics. Look at letters from the point of view of their structure and form but also how they sound. Replacing letters and groups of letters in relation to their sounds and perceptions will give you insight into the abstract and the ability to create your own codes and systems of expression. Keep in mind that all words have various properties, structures, sights and sound—ultimately their intent. You as the artist have the license to tweak it all as you see fit. Get out there and express yourself!

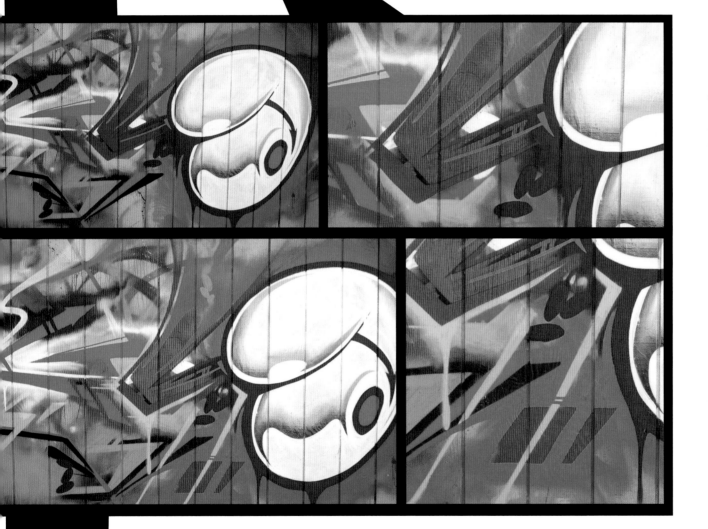

1 Drop in the **P**, again using the backward approach. You want the letter to be open, so the **P** isn't going to have a top to it, just a few gestures and strokes of orange paint to create the upper portions of the letter. If it's not a perfect flare, it could affect the piece, so practice before you execute. Over toward the **E**, drop in some more white to bring out the blue and flare the white outward.

2 This close-up shows the fill of the letter. It is in pink but pushed back and over as if removed from the outline. Yellow is used to create a drop shadow and fade away. Little nuances like this are key to creating work that is as individual as you are!

3 Using that same yellow, drop in the lower part of the **P**. This is a classic graffiti-style bar letter with a serif. Just do the outline and keep in mind that you want to separate the fill-in from the outline, where the orange slices will come in.

Tighten things up with the yellow and add drips, fades and horizontal paint strokes to bring attention to that area of the work. In some cases you may want to actually loosen things up with additional fades, blends and color splashes.

STEP 5: DROP IN THE LETTER X

1 Move to the right of the **A** and drop in the **X** with some super fat caps. Reach for a few colors that will bring some life like red, white and blue. This is where can control is key. Just do a few simple strokes—boom, boom and boom! The simplicity here is what makes it so striking.

2 Continue building the **X** with light blue. Take your time and use the same color for both the outline and shadow. Go back over it with some pink to crisp it up. Remember that placement is crucial, so you want the letter to just touch the **A**.

3 Using the same light blue, add in the lower portion of the letter. This is where your visualization skills are important. You need to know exactly where to cut the pieces off and where to pick up because there is no underlying sketch. As they appear, the random flare strokes are not so random. Add some slices to the lower left side of the letter to balance it out and add some style.

4 Grab another fat cap and drop in a renegade flare effect to shoot out of the bottom portion of the letter. Back it up with some white— a little stroke to the left and a drip and more white where the flare fades out. Come in with some lime green of the base color to add a little flavor with some extra lines along the edges.

STEP 6: COMPLETED PIECE AND DETAILS

1 Drop in the final messages and your tag, and boom you're done! **SOUL SEARCHIN** in the lower left, **SCAPE ≈ EPACS ≈ ?** was dropped in the lower right. Put in the copyright symbol, the year and your tag, and you can walk away knowing you did something truly original and unique.

2 Analyze the detail shots of the letters. The **E** is all about expression and less about pure letter structure. With the **A** notice how the red line ends with an arrow tip. The extra drip from the white adds value to the work. In the **X** you can see where black was added for contrast and balance, and that orange streak makes it all pop!

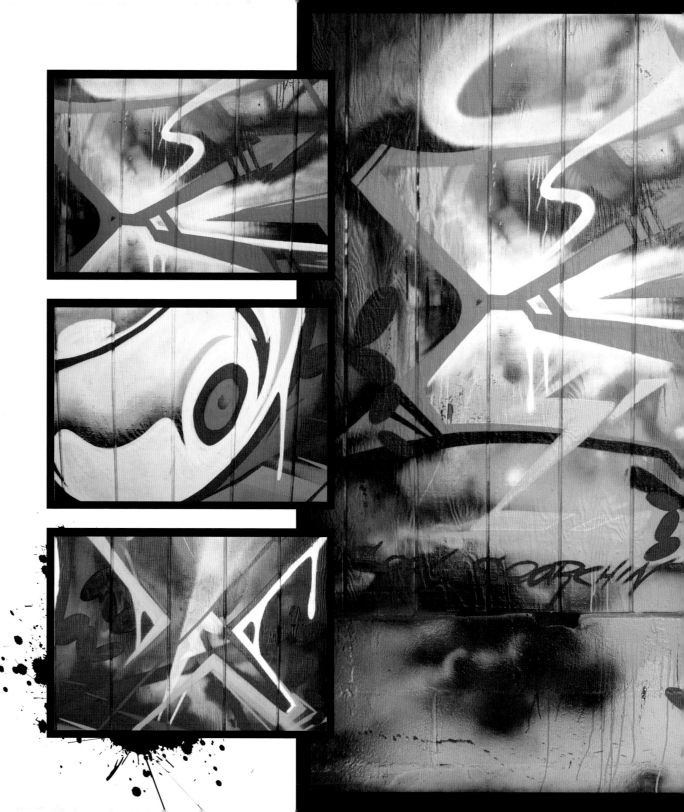

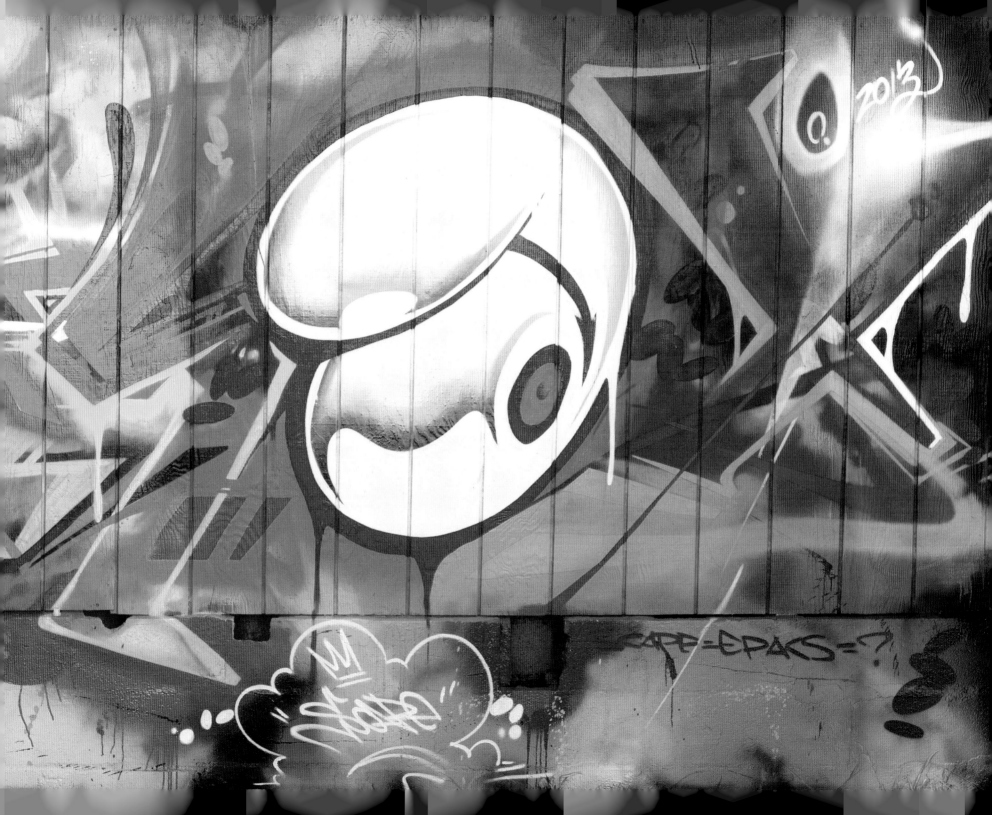

Permanent Midnight

In this experiment we explore the idea of transparent letters and letter abstraction by bringing in some extra tools: acrylics and lots of water! In this technique we want to be spontaneous and emphasize the *perfect gesture*. This means that your hand, arm and body movements work together to form your letters and colors. The paint will get sprayed onto the wall as well as splashed, splattered, brushed on and in some cases smeared. This is much different than in previous exercises where we have applied paint with surgical precision. Think of the letters as the framework upon which to be spontaneous and impromptu. As you work, ask yourself:

* What constitutes the outline of the letter?
* What can be a fill-in?
* Can the letters be flipped around?
* Can the outline of one letter be the fill-in for another?
* How can drips be an asset and not a liability?

The goal of this piece is to be dramatic and expressive, where legibility is not a concern. We want to play with some words and tie them to some style concept, which is **MIDNIGHT**. Let's rock!

PALETTE
Our palette consists of a lot of white and black accented with reds and greens. The blues will be our bedrock to build on. Our acrylic palette is made of yellow, hot pink, blues and plenty of water!

CANVAS
Our prime piece of real estate—our canvas—is a heavily textured concrete sand wall right by some train tracks. It's absolutely beautiful, only to be made even more beautiful with some screaming artwork.

SKETCH
Our starting point is a black-and-white line art sketch, almost a contour drawing. Drawing this way gives me room to breathe and improvise when I paint.

STEP 1: FIRST BACKGROUND (COOL COLORS)

1 Build on the blue foundation using acrylics. Begin to lay down deep sweeping strokes of acrylics—yellow, hot pink and blue. Start with the blues, working dark to light, then add the warmer colors after.

Allow the colors to drip in a random fashion. The goal is to build texture, so don't think about the letterforms. Work from right to left or left to right, then back up and view it from a distance. Be as nonobjective as possible and use liberal amounts of water to keep the acrylics flowing freely. Use both your brush as well as a sprayer. Keep your brush very wet and reach for the sprayer to increase the wash effect.

2 Add and blend various blues and whites to create your atmosphere. This is where your letters will spring from, so blend your colors creatively. You want to create a sense of depth and intricacy. Take your time. You do not want to paint over everything you just did, but add to it.

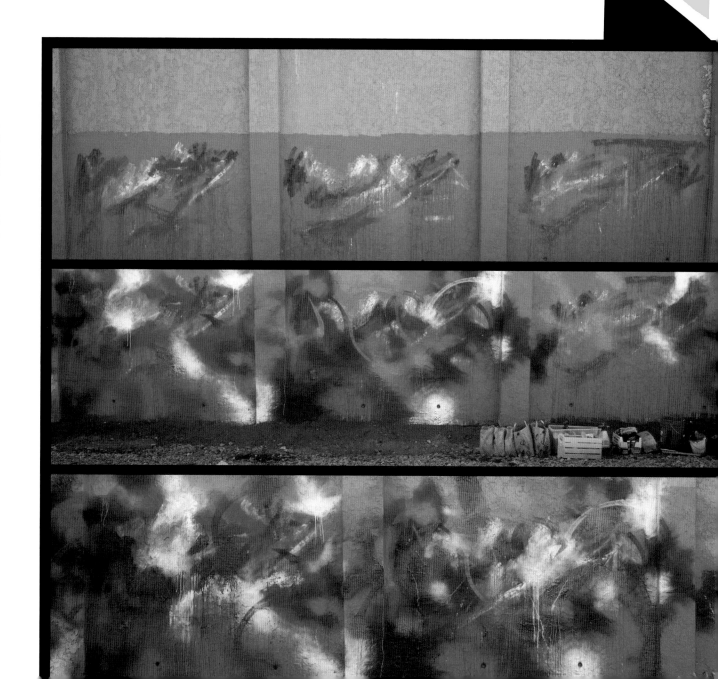

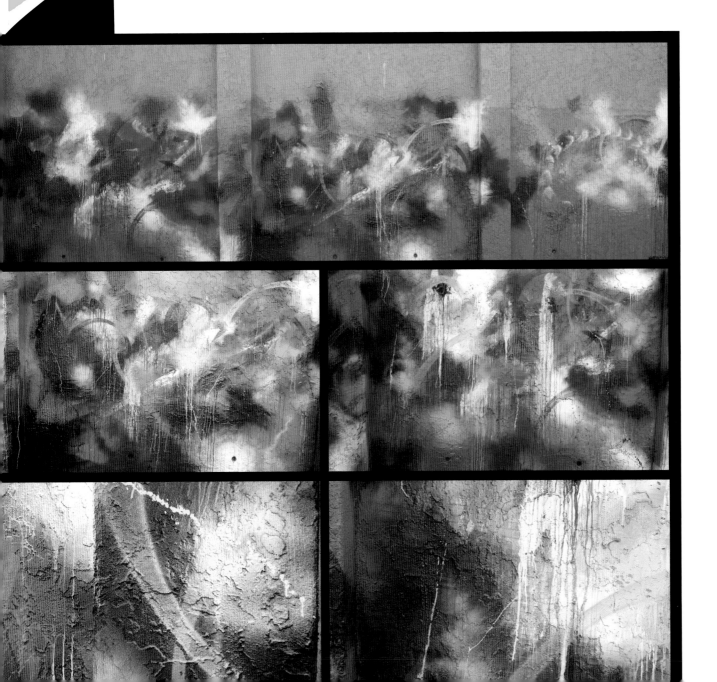

1 In the previous step we worked cool—now we work hot. Reach for your yellows, pinks and reds. Use both acrylics and spray paint and rotate between them. Do a pass of hot acrylics, then a pass with hot spray paint. Add splashes, drips and expressions to build tension and movement.

2 Examine these close-ups. You should be able to see all of your layers at the same time—the buff color, the acrylic and the spray paint layers. Strive for transparent flare effects to increase the movement in your work by moving the can very quickly across the wall surface. It allows for only a sprinkling of color so you can still see what's underneath.

As you add splashes and drips, keep in mind the rich texture of the wall. Allow the wall to do some of the work to result in interesting blends. Work with it and not against it. When you add a heavy brushstroke of acrylic, add a splash of spray paint to that area to create very robust color effects. You want the fluid properties of the acrylics to mix with the splatters and specks of color from the spray paint and vice versa. This translates into a visually interesting mix of both hues and paint textures.

STEP 3: EMBELLISH THE DETAILS

1 Use colors from steps 1 and 2 like light blue, yellow and hot pink to add unique dots, bubbles and color slices. Experiment with placement, and focus on creating movements that carry the eye through the entire piece.

2 Use your understanding of movement and color to place some curving arrows into the work. Add a splash of spray paint at the inception point, the exact point where the arrow begins, and fade it out so it appears the arrow is emanating from a cloud.

3 Back up and review, looking for areas that can be beefed up. You should have very few empty spaces. Add some more flavor to dull or imbalanced areas. Stop when you have a sense of satisfaction and have exhausted all opportunities to lay down acrylics. You know when to stop when you add more and it takes the work in a radically different direction.

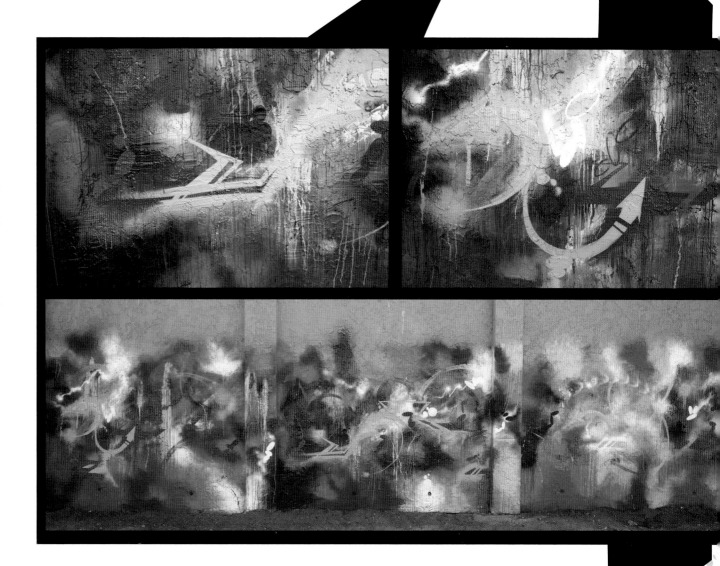

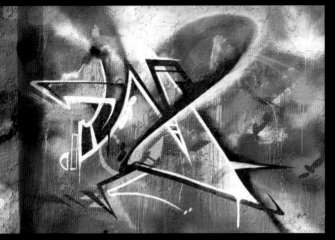

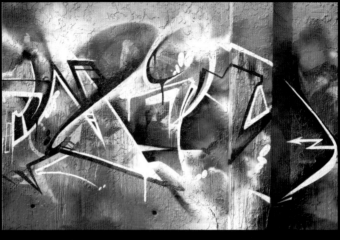

1 Reach for your black and your white and begin to drop in transparent **MIDNIGHT** letterforms. Transparent letters are not closed off and so they reveal the colors beneath (or inside). Alternate your outlines from white to black and so on. Use black liberally to add shadows and outlines. Make your letters stand out.

2 Continue switching out the roles of black and white to drop in the **I** and the **D**.

3 As you work, be mindful to switch out your caps and vary your can pressure as well. To create the second letter **I**, use a high-pressure white can and a super fat cap. The outline of the **G** fades out at the top in an exploding effect. This brings action to the letter, while adding black to the lower central portions of the letter adds drama.

TRANSPARENT VS. SOLID LETTERS

While a transparent letter is like a glass of water, a solid letter is a brick of concrete. A solid letter is your classic graffiti letter that you view as a sturdy object. You can put cracks in it or put it in 3-D . . . it's solid when it has a fill-in. A transparent letter is just an outline of the letter shape and can be broken up into contour lines. It's all about how you view the letter and objectify it.

STEP 5: COMPLETE THE LETTERFORMS AND DETAILS

1 Continue with your letters adding the **N** between the **D** and second letter **I**. The **N** is filled with black and a hint of white. Imagine the black as the inner shadow of the **N** with the white cutting in. The **I** is created from a series of expressive gesture strokes, and that is something that takes practice to get right and express correctly. It is about the gesture, the mark—that is where you feel your way around the work. Trace the letter's white outline with black and fade out.

2 This close-up shows the **T** and half of the **H**. Observe how the letters flow into each other as well as their fill-ins. The letters provide a framework for you to work your colors both within and around them. In the **T** the black works well both inside and out of the letterform.

3 Back up and review the piece from left to right. It should read like a visual piece of music, full of peaks, valleys, bumps and breaks—both loud and quiet areas. Take your time and note the areas that warrant more attention.

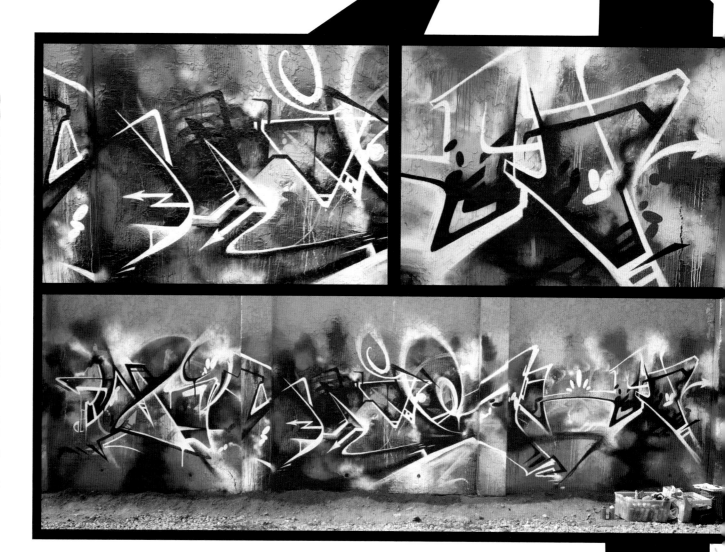

STEP 6: COMPLETED PIECE AND DETAILS

1 Add the finishing details to the areas that need it. Drop some more arrows in the lower left and right, and add some lime green to make some details stand out. Create a third outline with red that floats over the black and white of the letters. Sprinkle in more red and add some final black dots to the **I** and **G**. Add your signature and messaging and you're finished! Here I added the phrase **WALKING IN THE NEW** as well as my tag, the copyright symbol and the year completed.

2 Review the close-ups of **MIDNIGHT** to see how everything works together. Take mental notes of styles you like so next time you can push even further.

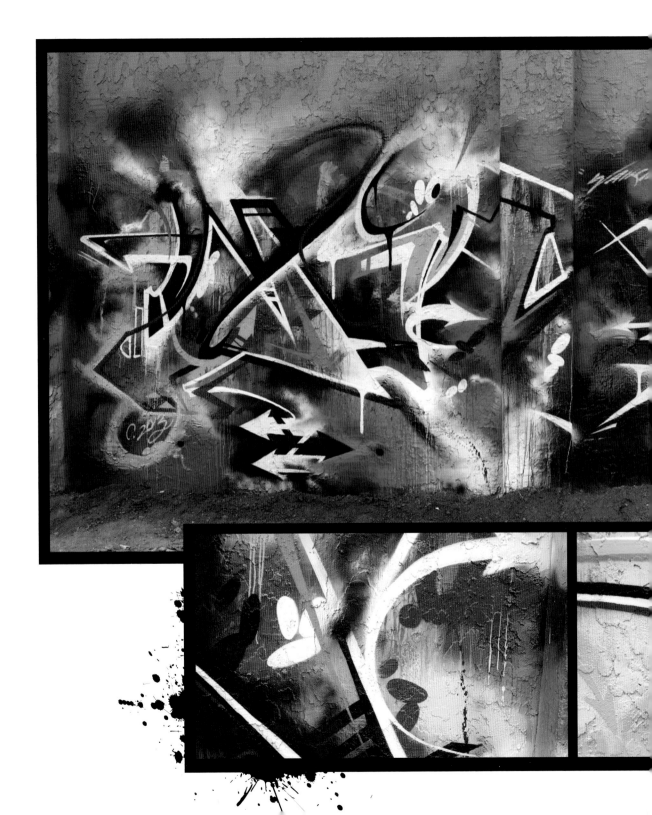

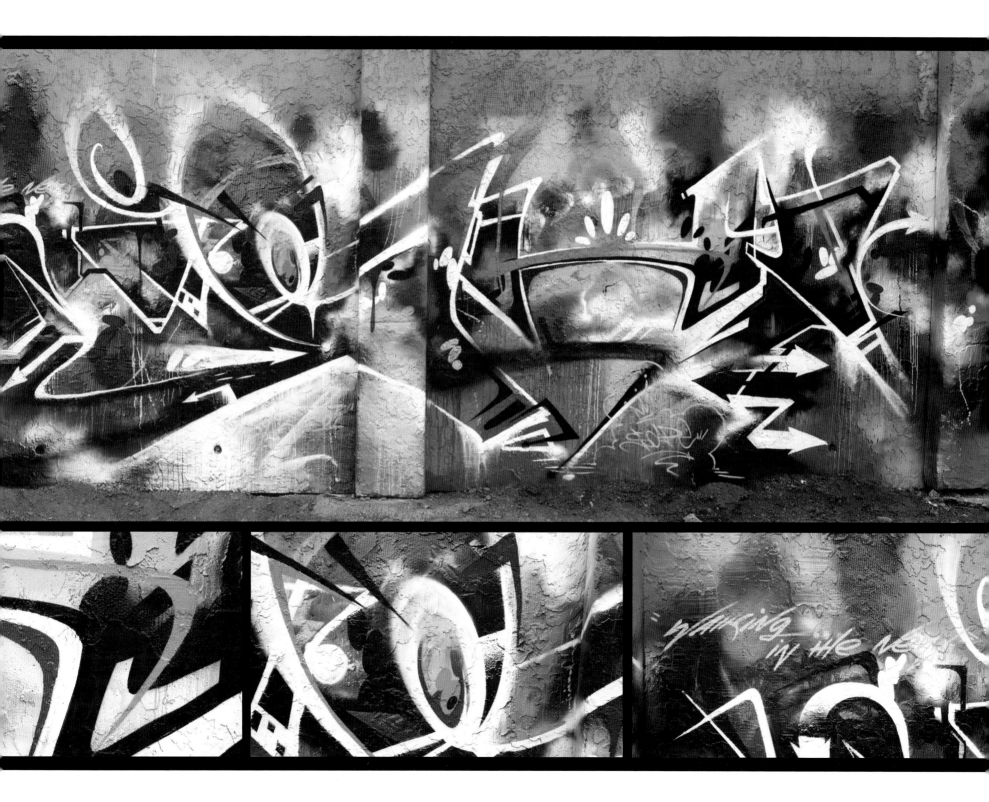

Blue Train Inside-Out Style

When teaching the art of graffiti, I often ask my students, "So what does your soul look like?" and "What color is your soul?" The answer helps prompt some interesting creative challenges and concepts like "How can you turn your letters inside out?" Our goal in this exercise is to release what is inside the letters, and to reveal what is inside the letters. Color and movement.

Color and movement are the soul of letters. In order to convey something meaningful and unique, you must break free from the constructs of the form and go deeper. Imagine a letter turned inside out like a fleshy piece of fruit, say an orange. What would come pouring out but the slices, bubbles, dots and unique expressions? The challenge is how to orchestrate and structure this in a discernible manner, not just a chaotic mass of color, which is both unpleasant to the eye and of little meaning.

In this demonstration we want to improvise to create movement and push our style to the edge. Focus on your color choices and placement to build a strong foundation. Try to stay clever and include repeated art elements to create rhythm, and some straight lines that are direct and harsh. At times we will work simple, other times funky. In the end a symphony will result.

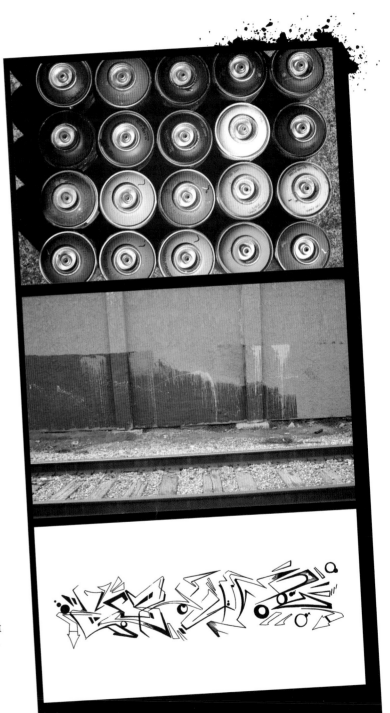

PALETTE
Our palette is made up of purples and hot colors as the two major color benchmarks, plus plenty of black and white. Interestingly enough, our palette contains no blues!

CANVAS
Our canvas is a heavily textured concrete wall buffed with a rich lavender color at left, gradiating lighter toward the right to promote eye movement. Two shades of pink are dribbled in the upper section of the buffed area and allowed to freely drip down. A bit of pink has also been splashed randomly across the surface.

SKETCH
This is our sketch, very simple, honest and direct. Notice the bold lines and calm yet dramatic dark spaces.

STEP 1: FIRST BACKGROUND

1 Layer various purple hues from dark to light. Place more dark hues on the left to create a pattern that fades from the edges and toward the center. This adds a bit of drama to the left that we want to balance as we work, which will help aid the viewer's eye move across the surface.

2 Lay in some yellow paint splatters using spray paint. Splash small amounts of color across the surface with yellow, lavender, pink and purple. I've used all spray paint to this point, but if you want, mix it up with acrylics as well.

3 Introduce pink spray paint to blend out and soften some of the harsh edges of dripped pink from the buffed wall stage. Do not paint over everything; try to leave some of what we did earlier to be seen. You should end up with three shades of pink layered throughout the piece.

4 Drop in some black sparingly to contrast the darkest purples. Use some black drips for added interest.

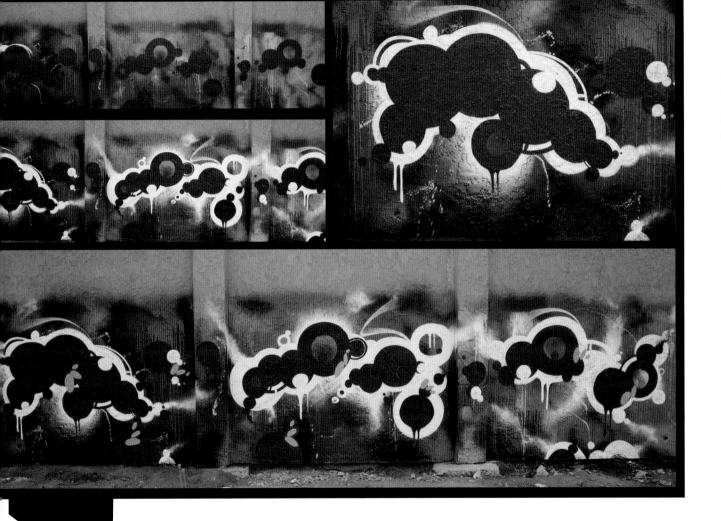

STEP 2: ADD ABSTRACT SHAPES

1 Reach for the red and begin to lay in abstract dots, bubbles and circles. Aim to create rhythm and movement! Connect them to create cloud-like forms; they need to be very large and spread across the surface. Work with the pillars as a part of your piece and don't allow them to divvy up the space. Treat the wall as one continuous space.

2 Outline the cloud forms with a very thick outline of white. Add a few white style elements like drips, fade-outs and flares. Drop in some white bubbles on top of the red to create negative space effects. Follow through with these ideas throughout the piece.

3 Step back and review. Does it flow? Does it move? Is there rhythm? Rework areas where your eye lingers too long. Tighten the clouds with more red or white, and use white to fade out into the purples in the background.

4 Lime green does *not* fit into our color scheme and for that reason, go for it! Drop in some classic Scape dots: three cascading oval patterns. Judiciously place them in key areas of the work—directly over the red, close to the edges and then floating off into the white or into the background.

STEP 3: DROP IN THE LETTERFORMS

1 Using your sketch for reference, begin dropping in the letterforms—**BLUES**—using only black. Be careful with your placement because it's difficult to go back and fix. The letters should be the framework to let the colors flow outward!

2 Back up and review. You should be able to see a minimum of four layers: the initial buff colors and drips, the atmospheric spray paint of the first background, the cloud and circle patterns, and the letterforms on top. Let your eyes explore the piece and discern. Where is it falling off, where does it need tightening up?

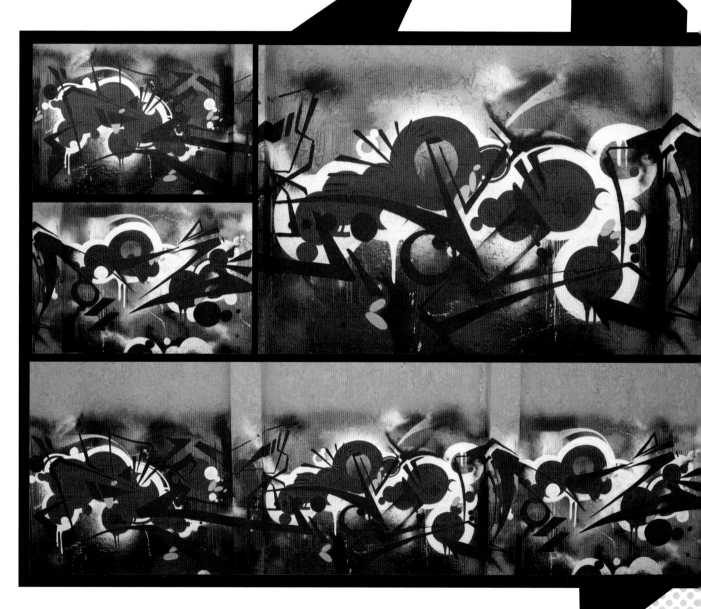

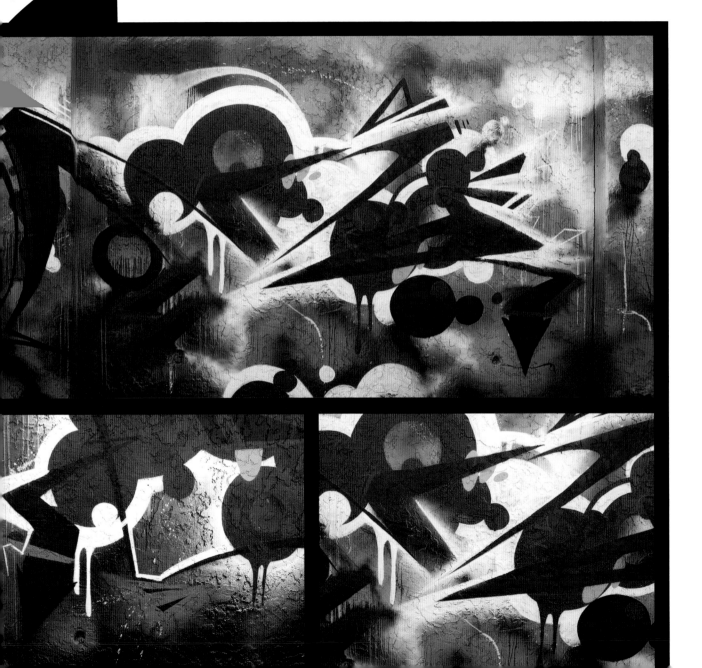

1 Cut out portions of the black letters with white to make some edges crispy. Begin to fade some of the central areas of white from hard to soft edges. If one edge is hard, soften it on the other to increase its depth perception. Do the same thing with purple and with other parts of the letters. Walk about the piece and tighten up the arrow tips and add a few purple dots on top of the black dots.

2 In these close-ups, notice how the white serves as an outline and as a drip. It also is the shine for the black outline, the classic graffiti-style highlight on the inside of the black letter outline. In this piece, white performs many functions in a very tight space. Don't worry about painting over any of the green dots; you will have the opportunity to go over it again. Discern and observe.

STEP 5: ADD THE FINAL DETAILS

1 Now that we've got our transparent letter-forms placed, it's time to show what's inside of them. Drop in slices and cuts with two shades of pink, green and orange. Dictate the color in a staggered fashion from thick to thin to thinner. Add bold strokes and lines of orange and pink.

2 Back away and observe again. Your orange, pink and lime green details should float on top of the piece. Go back in with red to tighten up the black where needed, creating nice, crisp edges.

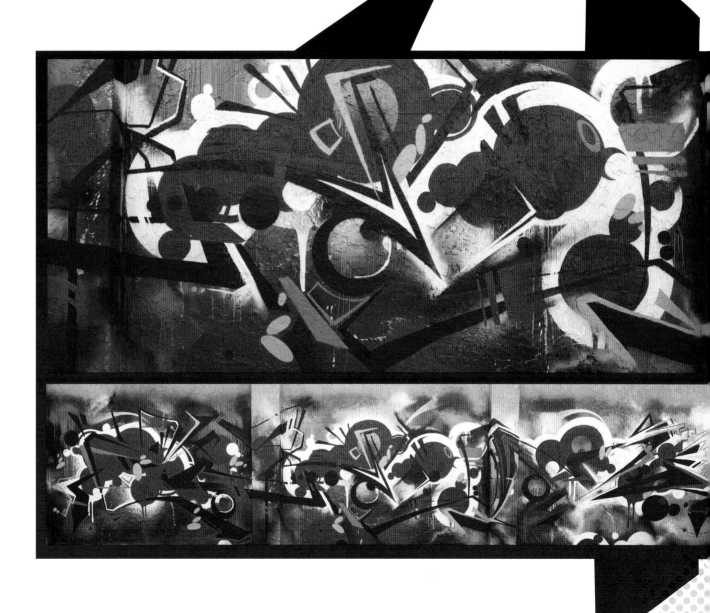

STEP 6: COMPLETED PIECE AND DETAILS

1 To set off the piece, reach for bright yellow, a super fat cap and a skinny cap. With the fat cap, go wide and loose, adding a wavelike flare effect. Change to your skinny cap, and with the same color continue the stroke with an arrow tip at the end. Add your quotes and your messaging, and there you go! Walk away and exhale because you just did something great!

2 The detail shots show my messaging: **SOMETIMES IT'S WHAT'S MISSING** and **THE SOUND OF SCAPE.** Look through the layers at the textures, feeling and expressions.

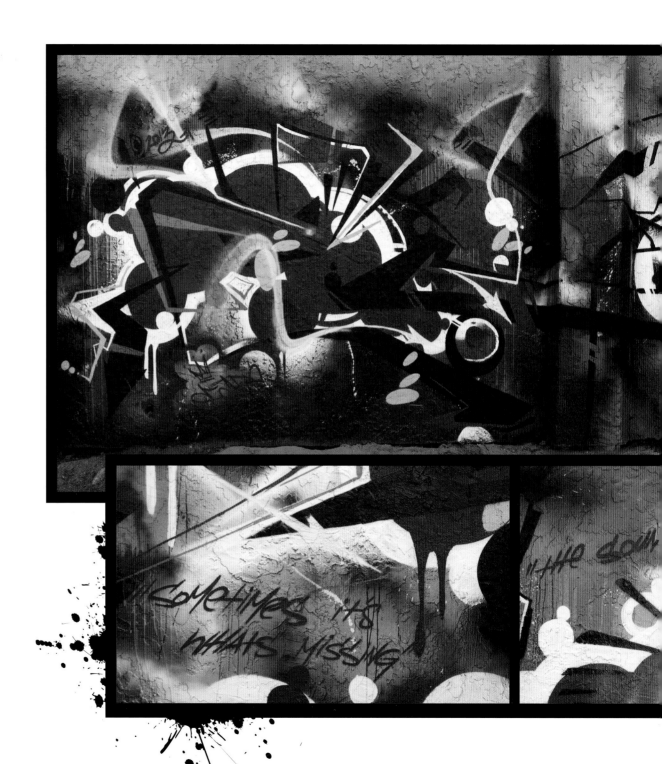

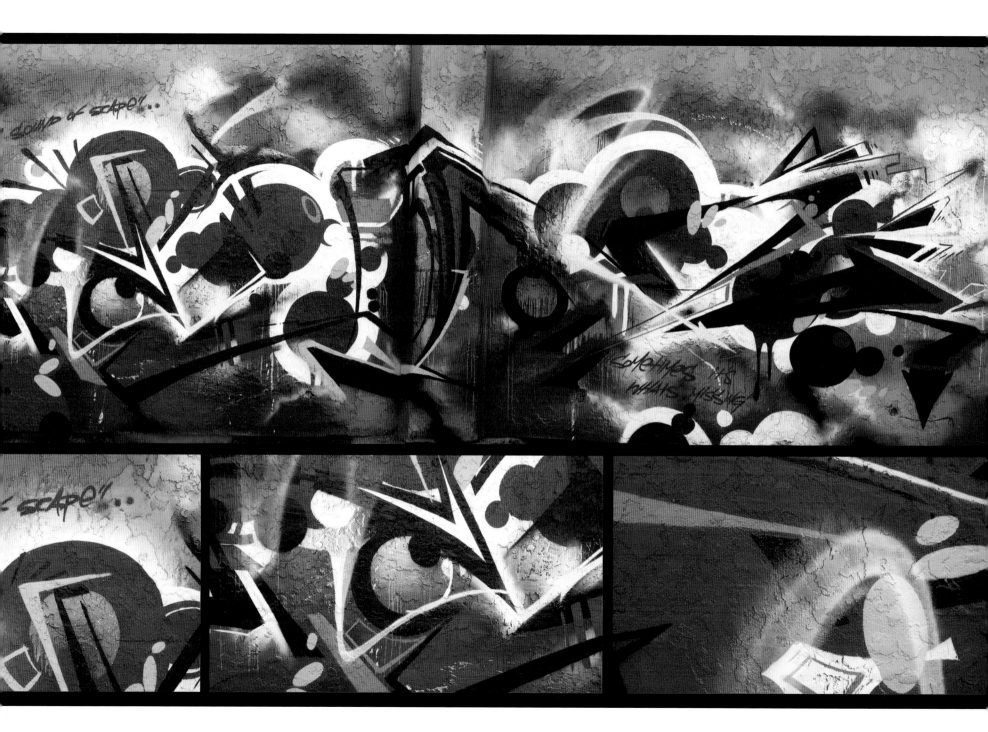

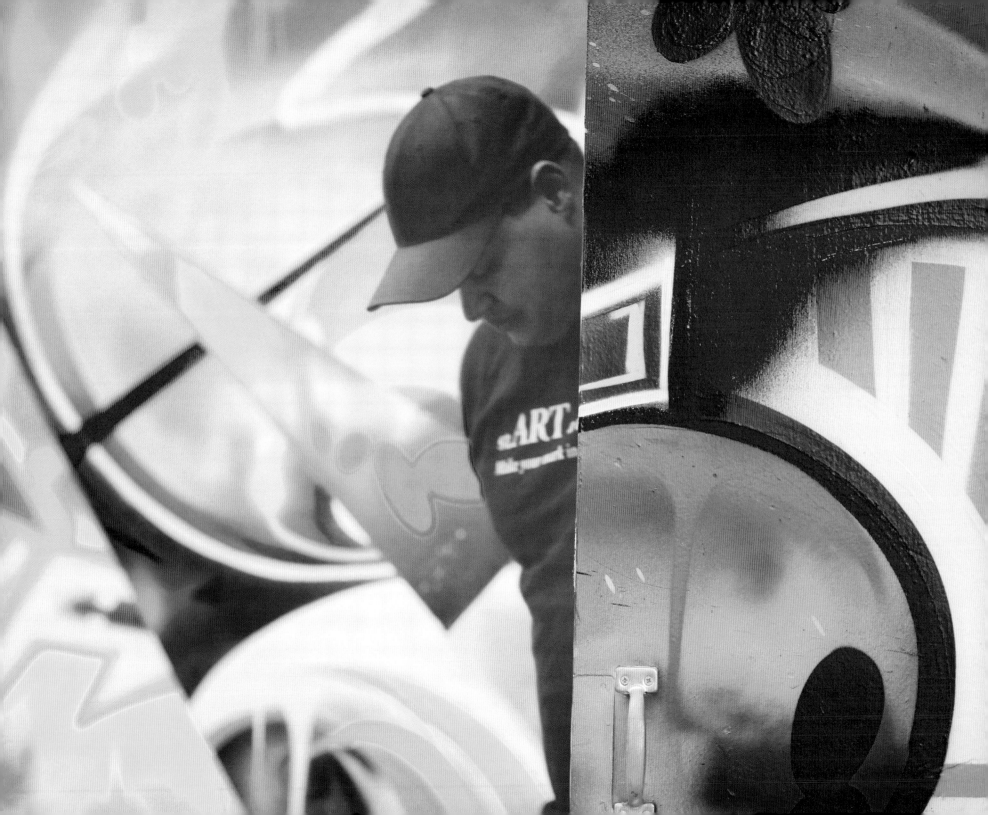

The Future Is Now

Up until now we have focused on spray paint and outdoor walls, classic interactive graffiti intended for public consumption. Let's take our color education to the next level and try our creativity on canvas in a controlled indoor environment. Practicing your raw graffiti techniques on paper and canvas is a great way to keep your art fresh and full of energy. Working indoors allows you to experiment with new tools and types of paint. Ask yourself, what happens if I mix acrylic painting techniques with spray paint? What happens when I hold a spray can in one hand and a paintbrush in the other?

In this chapter we explore some acrylic painting topics and techniques such as tints and shades, glazing, color washes and other color theories, all mixed in with conventional spray paint techniques. Building your traditional art skills and mixing them with graffiti will help you improve the style elements of your letters as well as your can control. Whether your focus is a monochromatic painting, a purely abstract work or a hybrid of styles, reach to explore new expressions and color techniques. Impose your will on the blank canvas. Don't fear the future, it's here already!

Tints and Shades

Tints and *shades* are important parts of color theory. A tint is when you mix any color with white to increase its lightness, and a shade is when you mix a color with black to reduce its lightness. Make sense? A tint is sometimes referred to as a *pastel* because of its lightness. As a color gets lighter, the contrast between it and the colors next to it decreases. On the flip side, shades help create drama and mood in your work. Tints and shades really work best together!

When working with tints and shades, keep in mind that there are many types of blacks and whites. A color may appear to be black yet truly be a deep hue of gray or dark purple. Conversely, a white like Titanium White is slightly different than Ivory or Titan Buff. Be aware of what you are working with because these derivatives shift the hue when mixed.

Saturation is a color's intensity. It is not so much how light the shade or dark the tint, but how pale or strong the color is. This depends greatly on what colors appear next to a color, or what light you are viewing a piece in.

Also note that you cannot mix spray paint out of the can in the same fashion as acrylics. A graff artist tends to think of everything as a color. If it comes out of the can, it's a color; there isn't any tint/hue/shade differential. In this way, working with acrylics will improve your overall understanding of color. Understand how tints and shades work to push your vision into reality!

WORKING LARGE AND IN CHARGE
When graffiti artists move indoors, I've noticed they often try to take something that is innately large (the graff) and cram it onto a small working surface. Don't be afraid of working on very large canvases. You've got big ideas—work big and don't leave anything out!

Tints 101: Adding Black: Here we are looking at three primaries—red, yellow and blue—broken up into six visible steps. The base colors progress left to right as black is added. Observe how the yellow drifts into a green. As you practice, add black to colors sparingly because using too much can drastically alter the base hue or make your subject too overpowering.

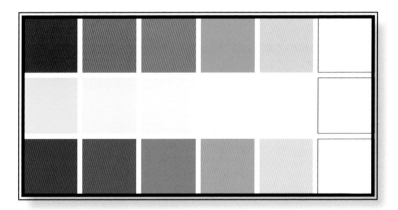

Shades 101: Adding White: Here the red, yellow and blue gradients drift left to right gradually becoming pure white. The more white the color has, the softer it appears.

EXPERIMENT WITH COLOR GRADIENTS

Here we have three acrylic paint examples based on the CMYK color model—cyan, magenta and yellow—each progressing to white in the left column and black in the right. Experiment mixing tints and shades in acrylics and oils to learn how the paint mixes and spreads. Learn how to control the mediums and the mixtures to give you a sense of purpose and understanding in your work.

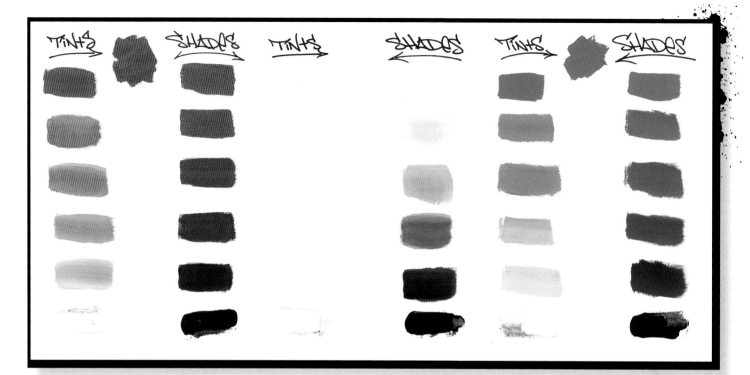

COMMON COLOR TERMS

When speaking about color, memorize these terms; they are not interchangeable:

Hue—the absolute pure color

Tint—the hue plus some white

Tone—the hue plus gray

Shade—the hue plus some black

BLENDING ACRYLICS

In this example we use acrylics and blend our colors left to right. To the right are tints, and to the left are shades. Understanding their interplay is crucial as you move forward. You can create similar fades with spray paint, but you typically have more control with acrylics than the drippy nature of paint straight out of an aerosol can.

Glazing

Glazing is the artistic application of thin layers of semitransparent paint through the use of gels or glazing mediums. The purpose of glazing is to add luminosity, layered effects and an increased sense of depth to your artwork. In glazing, you apply the diluted paint mixture just light enough to show the layers underneath. Those layers underneath can be earlier strokes of paint, raw canvas or in our case, layers of spray paint. It is very important to let your layers dry thoroughly before applying another coat of glaze.

Working with glazes changes the value of the surface beneath. Some colors work better than others in the glazing process—colors such as Quinacridone Violet, Phthalo Green and Cadmium Yellow. Drying times differ depending on the amount of paint, medium and water used. Keep the use of water to a minimum, as you want to create a glaze and not so much a wash. In a nutshell, the more medium you add to the paint, the more transparent it will be; the less medium, the more opaque.

Patience is key when glazing layers. Adding layer upon layer will allow you to create very rich and luminous spaces with truly intense colors. All of these color areas can be magnified with the use of spray paint as a part of the layering process. By glazing tints or shades over a layer of spray paint then adding more layers of spray paint, you can create a sense of depth in the piece.

self-leveling clear gel
glazing medium

GEL MEDIUM

I use two types of gels: Self-Leveling Clear Gel and glazing medium. I like to mix them together with a small amount of water to create a rich, fluid gel mixture. Do not worry that the mediums look milky and white when wet; they dry clear.

Heavy vs. Fluid Acrylics: Heavy acrylics are smooth, thick and opaque, while fluid acrylics are of high intensity and runny. In glazing, heavy are great for building up textures and gradients while fluid are better for creating thin films of color and subtle effects.

TOP: heavy-body acrylics, left to right: Cadmium Orange, Yellow Orange Azo, Dioxazine Purple, Medium Magenta

BOTTOM: fluid-body acrylics, left to right: Phthalo Green, Quinacridone Violet, Ultramarine Blue, Pyrrole Orange

1.5-inch (38mm) flat 3-inch (76mm) flat

PAINTBRUSHES FOR GLAZING

To glaze, I use 1½-inch (38mm) and 3-inch (76mm) flat brushes. The smaller brush is great for tight spaces and quick, neat strokes, while the wider flat brush allows you to spread your glaze farther and faster.

dark to light

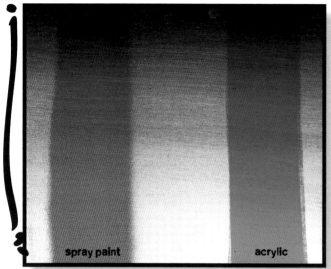

spray paint acrylic

GLAZING EXERCISE 1: SIMPLE STRIPES ON CANVAS

In glazing, we can create luminosity and depth in our colors by layering acrylics mixed with gel medium. To start, create three stripes on a canvas surface. Here the hot pink is spray paint, the blue is acrylic and the middle stripe is raw canvas. Using a flat brush and Dioxazine Purple heavy-body acrylic paint, create a gradient from dark to light, starting at the top and working downward. Begin with pure hue straight out of the tube and add gel medium as you paint downward. Adding more medium makes the purple more transparent. Note how it interacts over both types of paint, creating subtle color shifts.

GLAZING EXERCISE 2: ACRYLICS OVER SPRAY PAINT

Create a few random curved lines with spray paint—the curves promote movement. Here I used, hot pink, intense red, shock green and sky blue. I used curved lines to promote the idea of movement, glazing some of the colors from the corners toward the center. Shown clockwise are Dioxazine Purple, Phthalo Green, Cadmium Orange and Yellow Orange Azo. The idea is twofold: observing the interaction between the spray paint colors and the glazing and seeing how the hues shift. Because the colors shift from opaque to transparent, it promotes movement, making your eye travel across the canvas.

GLAZING VOCABULARY

Glaze—the mixture of the hue (paint), gel medium and water

Layer—either paint or a glaze. Think of a stack of playing cards and each card is a color or glaze. When stacked, they create the end result that you see.

Medium—the fluid that is used to thin paint to create the glaze

full hue

light dark

transparent

GLAZING EXERCISE 3: LAYER A LETTER

Outline the letter **S** on canvas with permanent marker, then break up the space with thin lines, creating four to five random bands left to right and up and down. They can be as random as you like.

Begin adding layers. Start on the left side with pure opaque color and increase the amount of gel medium as you move to the right—essentially going from light to dark. Allow what's underneath to show. Remember to let the glaze dry before adding another layer. Be patient and observe how the layers overlap to create new colors while shifting the chroma and hues underneath. As you continue left to right, notice the areas that pop out from increased contrast and the areas that recede where the hue is pushed back. Continue to layer to your heart's delight, and when complete, re-outline the letter to see the final result!

Color Harmony

Color harmony is achieved when color relationships in your piece are viewed as successful and pleasing. Though this can very much be a matter of personal taste, understanding general color schemes and ideas can help point you in the right direction in your work. In the end color harmony is about balance and symmetry.

There are two ways in which we respond to color harmony: cerebrally and viscerally. The *cerebral* method deals with the direct meaning of colors and our intellectual association with them. The *visceral* method is our emotional response to color combinations. In graffiti art we tend to view color more through a visceral lens, where traditional art forms are viewed through more of a cerebral lens.

When we discuss a piece's color harmony in the simplest terms, we ask ourselves how well colors do or do not work together. This is most often an individual, personal experience. Color harmony can also be subjective because what may work today may not work in the future. Some color schemes are timeless, such as light blue, white and dark blue. Others, not so much. Think of the changing fashions and interior designs over the years. It is normal for popular color combinations to ebb and flow throughout the years.

As you seek to achieve color harmony, remove the barrier of specific terms such as "graff art" or "acrylics" and view all of your tools as working together. Understand and apply the principles in this chapter to help you get there faster and less by chance.

FOUR COMMON COLOR SCHEMES

Based on a standard color wheel, here are four color schemes that technically work together. Use this as a guide to build your own personal aesthetic in your work.

★ Complementary—colors that are directly opposite each other on the color wheel. For example: red and green, blue and orange, yellow and violet.

★ Analogous—a combination of colors that are spaced side by side on a color wheel. For example: red, orange and yellow.

★ Triadic—three colors that are equally spaced apart along the color wheel. For example: red, yellow and blue.

★ Monochromatic—colors that are based on a single hue. For example: dark blue, true blue and light blue.

VISUAL IMPRESSION

Look at the palette that was used for the artwork. Notice the pure hues and not the secondary colors created by the blending, fading and mixing of the hues. Does the palette work? If so, why?

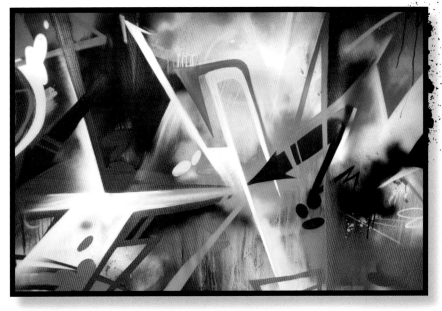

COLOR HARMONY: MONOCHROMATIC

COLOR HARMONY: TRIADIC

COLOR DISHARMONY: POOR CONTRAST

COLOR DISHARMONY: NO BALANCE

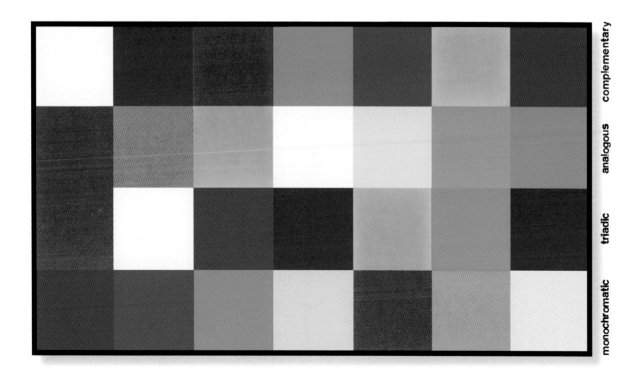

complementary

analogous

triadic

monochromatic

EXPLORING COLOR HARMONY

Explore working with useful color combinations through experimentation. All pleasing color combinations have one thing in common: They stimulate the viewer's brain. Besides beauty, the brain looks for many qualities when examining color: contrast, color complements, intensity and balance.

81

ISM

In this exercise we experiment with color on canvas by laying acrylic washes and applying spray paint on top. What exactly is an ISM? It's the suffix commonly used in many familiar words from politics to philosophies to art movements. We have abstract expressionism, minimalism, realism—but for the sake of our work, we attach it to our tag creating *Scapeism*. Try it with your tag and see what images conjure up in your mind.

When I ponder the meaning of Scapeism, I envision an elevated style. It's not a tag style or a throw up or even a burner; it's something totally new. Something that uses a lot of color, pushing the envelope of what graffiti art can be. In this demonstration let's rock the inside-out letter technique as shown in the Blue Train demonstration. We are going to fragment our letters, showing less of the letter style and more form and individual lines. By allowing the colors to flow yet collide, we can create an element of surprise and some serious chaos outside of each fragmented letter.

PRIMER PALETTE
For the canvas's base choose two contrasting, complementary colors. Orange and blue are complements, so here we have a very rich turquoise and a very hot orange.

CANVAS
Our canvas is 8 feet (2m) high and 12 feet (4m) wide. Place the two primer colors at an off-kilter angle, roughly 45 degrees.

LETTER PATTERN
This is our letter pattern— broken up, deconstructed and turned inside out.

STEP 1: FIRST ACRYLIC WASHES

1 On the teal top half of the canvas, lay down a thick acrylic wash of Phthalo Turquoise, Cobalt Teal, Magenta and yellow using a 4-inch (100mm) flat brush. Use a liberal amount of gel medium and allow the colors to run free; you can either mix the gel medium into the paint or apply it directly on the wall. Apply the darkest values first before the lightest to create interesting layers of color. Allow the layers to build in interesting gestures, textures and in the end, layers of colors.

2 In these detail images notice how the thinned paint runs together, creating ideal rivers of color. Do not paint completely over the base hue; instead continually add to it. A few words of encouragement: do not fear the drips! Experiment to see how colors flow and work together.

3 Repeat the layering and dripping of paint in the lower orange area using three shades of color: red-orange, yellow and a little white. Build up the layers with heavy brushstrokes to create rich colors, increasing a sense of depth perception in the work.

4 As you can see in these close-ups, the process is precise though the results seem carefree. Blend in the turquoise that runs into the orange half. Make sure that the colors you use retain as much of their vibrancy as possible. If your colors begin to overly mix and create mud, slow down. Add paint wherever possible and practical.

1 Reach for your spray cans and get expressive! For your initial marks just spray, splash, flare, repeat! Go with a deep burgundy at the split edge of the orange and turquoise, then add some oranges, yellows and whites to balance the rhythm of the piece. You are not trying to paint over everything, just adding to the composition.

2 In these detail shots you can see the delicate nuances of oranges and yellows rather than one giant mass of orange. By adding a wash of acrylics and coming on top with spray paint, you achieve a variety of layers and patterns. Some utterly random, some automatic and some deliberate, but in the end the results are robust.

WALL VS. CANVAS

There are many benefits to a graff artist working on canvas.

★ Freedom to create ideas that are not limited to wall space.

★ The ability to create work safely and without outside distractions.

★ Creating a work that is portable.

★ Allows you to take more creative risks.

STEP 3: ADD LETTERS AND DETAILS

1 Using some can control, add some more flavor to the lower orange section using the same colors as in step 2. Drop in dots, bubbles and slices of colors and be as expressive as possible.

2 Using your sketch as a guide, cut in and drop an inverted **S** letter using yellow and a fat cap. Keep your initial marks loose, expressive, open and easy to see. Outline the top of the letter with white and the lower portion in turquoise. Change the color elements as you work to keep it interesting. Add a black arrow pushing forward from behind the slice of white—all of these details are part of the letter structure!

3 Drop in the letter **I** to the right of the **S** with true blue and turquoise. Double up your lines so it's as if you are looking at a window. For now, focus on the area within the orange space; the other linework is a reference for later.

4 Drop in the **M** with light blue and take note of how the letterforms are taking shape. Our goal is to create something mind bending! The **M** should overlap and interact with the black arrow, so work it over, under and through that form.

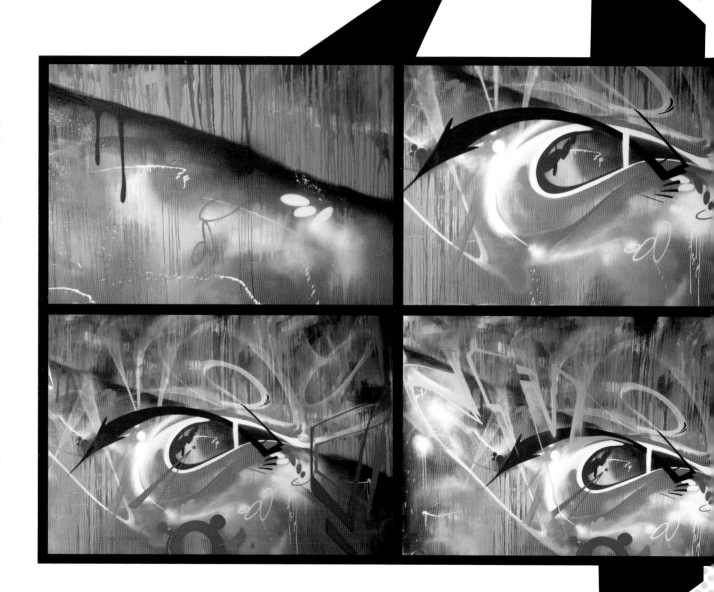

85

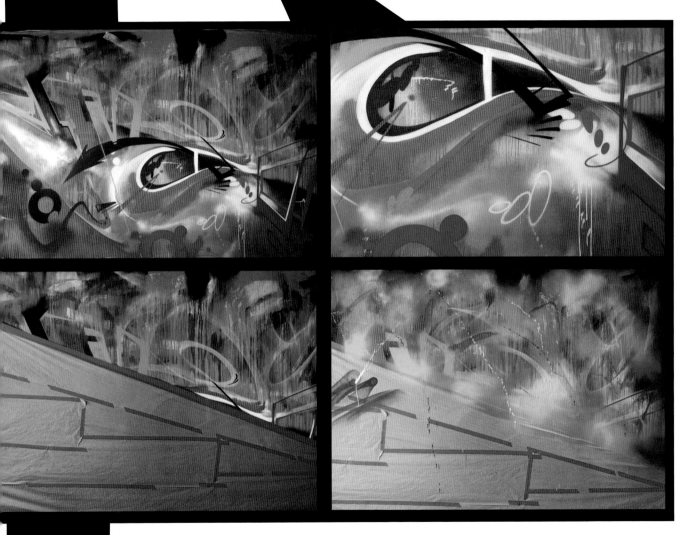

1 Using all of your previous spray paint colors, correct and shade where needed around the letters. I use my black spray paint similar to a charcoal stick. I try to push the color around to emphasize the colors surrounding it. Use black to add a few circles where the arrowhead is pointing. Add a few drop shadows and flares on the letter **S** with red. Work with both positive and negative space, allowing your eye to bounce across the piece.

2 Tape off all of the orange area with painter's tape and painter's brown paper. Make sure the lower portion of the canvas is completely covered and that the blue tape is pressed down firmly to prevent any seepage of the paint.

3 Build up more layers with spray paint using hot pink, yellow, lime green and turquoise. Focus on the taped edge, adding lighter hues to those areas. Try to achieve a great sense of depth with your splashes and drips, allowing them to intermingle with the flare effects and letterforms.

STEP 5: COMPLETE THE LETTERFORMS

1 Outline the top half of the **S** with red, then add lighter values such as white and yellow to the inside. Use your memory to envision the lower half that is still covered with paper. Add additional fades and color slices with green, red and yellow, and a second bold black arrow.

2 Move onto the **I** and switch up your colors. Each letter needs to be different. Outline the letter with white and orange. Blend, tuck and slice using yellow. Your first goal should be to let the letter stand out, then blend the edges of the form into the prevailing composition.

3 Drop in the top portion of the **M** with hot pink, red and lime green. When you are satisfied with the final details, carefully remove the tape and paper.

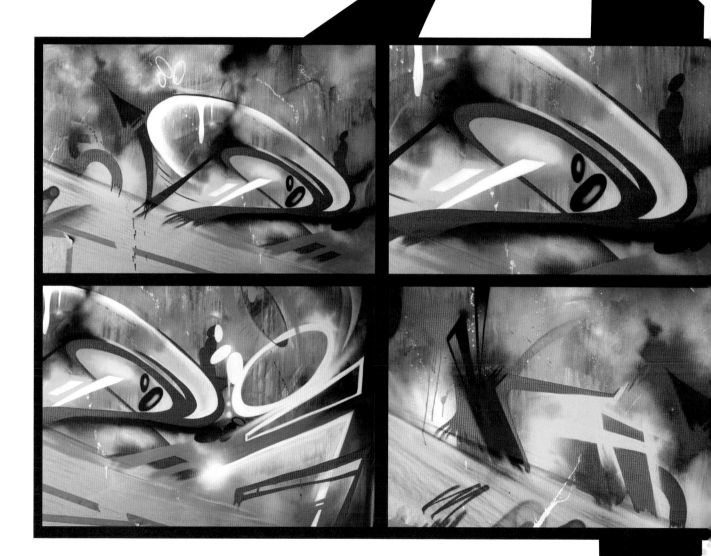

STEP 6: COMPLETED PIECE AND DETAILS

1 Step back and review the canvas, adding details and expressions as you see fit. I dropped in a few more bubbles, while being mindful of the diagonal split of the composition. Don't forget your tag! The finished piece is organized and controlled but also chaotic.

2 Take a look at the detail shots and notice how the colors bob and weave. The orange clashes beautifully with the turquoise, creating two pieces that blend as a whole. Ruminate on the differences and observe the similarities. Exhale and enjoy!

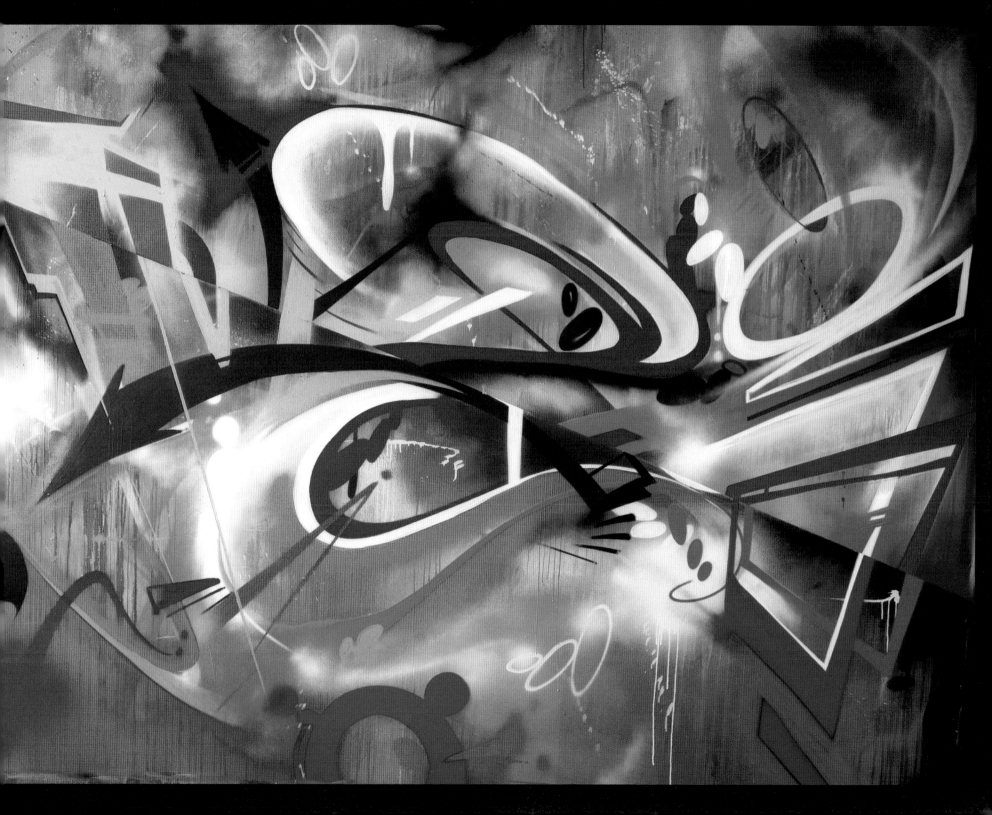

S·C·A·P·E

What is the crux of what the viewer should take away? What is it all about? In this demonstration we will practice this concept on canvas and wood. We will be painting on five canvas panels stapled to wood creating one large piece. This type of large graffiti piece actually yields multiple pieces for hanging though it's painted as one. In each of the five areas you can develop multiple focal points—sweet spots that the eye is naturally drawn to. You can get creative where you want to add some action and funkiness.

DEVELOPING YOUR STYLE

All of us start out from a similar place. You want to know more about street art and graffiti, so you seek out the people who create the art. You practice and spend years drawing and writing in sketchbooks and mastering your tag before you go out in public with it. Over time, you will develop and move from basic styles and color patterns to more intricate ones. Practice eventually pays off, and the end result is a visual art style you can call your own.

PALETTE
Our palette consists of primary and secondary colors, and a pure white gesso as the base primer for the canvas. Since the basecoat will also be a part of the final piece, white is the way to go.

CANVASES
First I set up five wooden panels each 4 feet (1m) wide by 8 feet (2m) high, 20 feet (6m) wide in total. I angled the panels outward to help create interesting results. Five canvas sheets 4 feet (1m) wide by 4 feet (1m) high were stapled to the center of each panel, slightly overlapping each other.

STEP 1: TRANSFER YOUR PENCIL SKETCH

1 In my sketch I tilted each letter of my name clockwise 90 degrees at each letter. Plan out the unique elements like arrows and bubbles. .

2 Lay down your initial sketch with blue spray paint. Work loose and free, folding each letter into the next. Think of the panels as one whole piece, ignoring the individual canvases. Step back and review. Have you captured the essence of the sketch? Continue to improvise where you see fit.

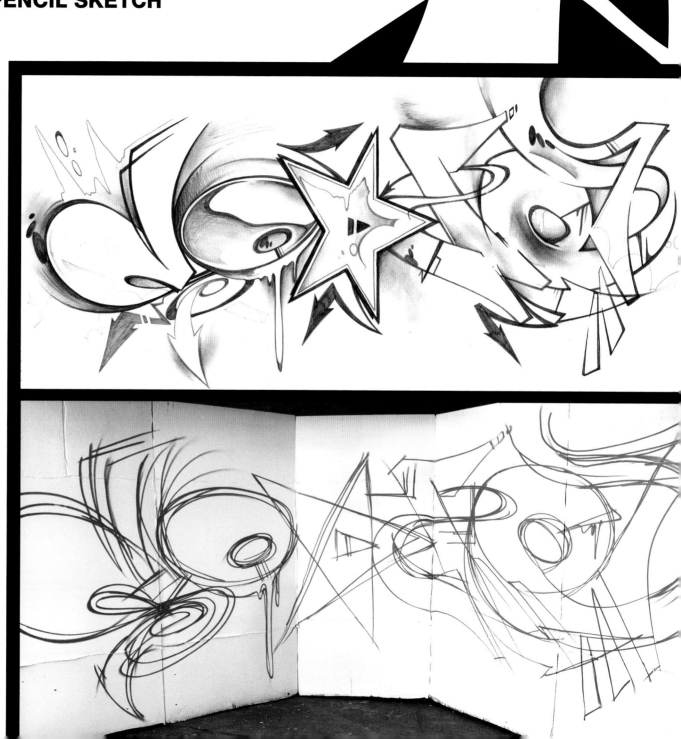

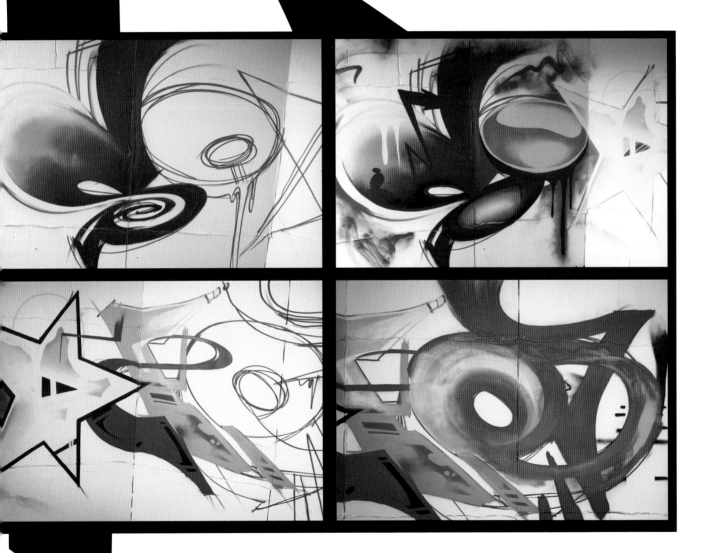

1 Working dark to light, lay in the **S** with pink fading into the white basecoat. Work dark to light then light to dark, and back again with darker pink. Try to capture movement and energy using just three colors of spray paint.

2 Render the **C** with gold and the **A** with white, creating subtle cloud effects in the star. Switch up your colors when switching from your outlines to fill-ins and textures. As you move through the piece, flesh out details in the previous letters, reacting with colors as the letters unfold. I added some white drips on the **S** and gray shading over the **C** in the background.

3 Outline the star (letter **A**) with red to make it pop. The letters should appear to roll along so that the **P** is actually upside down. Render the **P** with blues and inject a touch of red from the previous letter into the darkest blue areas. It is perfectly fine to take a little bit of flavor from the previous letters and sprinkle it around!

4 The **E** is behind the **P**, not alongside it or in front of it. Block it in with a few shades of orange, gradually fading the different colors into each other. Use a fat cap for the circular motion in the middle of the letter. Sprinkle a little bit of white on top in a circular motion to add a sense of depth.

STEP 3: OUTLINE THE LETTERFORMS

1 Outline the **S** with true blue to make it pop. Be very careful as you outline, applying color in an almost surgical manner. Blue is the complement of orange, so it works well next to the gold **C**. This is a nice balance of warm and cool hues.

2 Outline the **C** with a shock green to make it stand out as well. As with the **S**, we want to create an outline that glows and bounces energy from both letters. Add a few details inside the letter and a touch of black to make it appear reflective.

3 Apply the warm vs. cold color concept to the **P** and outline it with hot pink. Add any details that you see fit like slices, bubbles, dots and other expressions.

4 In this detail shot note how the red from the **A** is pulled into the blue, and the hot pink wraps around the orange. Add drips and expressions with the pink, then go back in with blue. Go back through the piece and tighten up your fill-ins—don't be scared to slice it up and make it crispy.

5 Outline the **E** with purple to make the letter leap off the wall. Tighten up your orange fill-ins and slice into the purple. Review the piece. Go back and add some red slices in the central area of the letter.

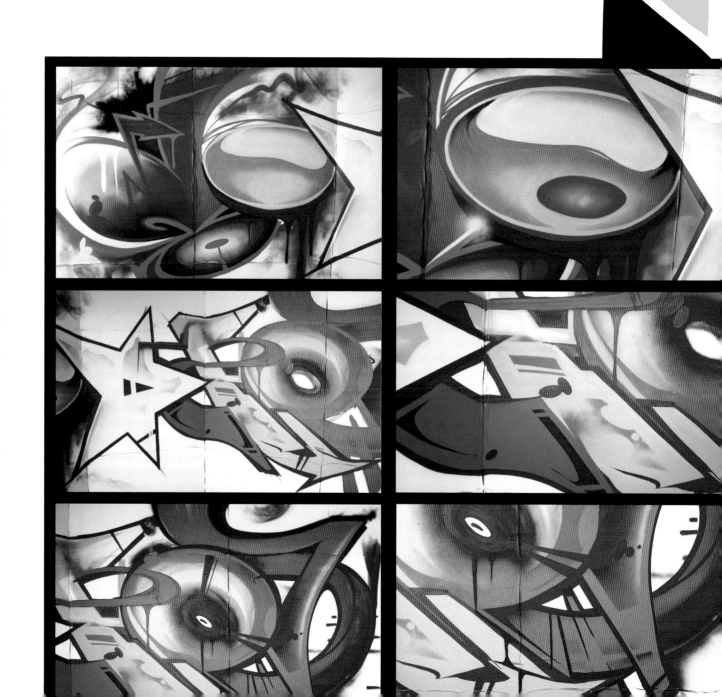

STEP 4: ADD THIN OUTLINES AND DETAILS WITH WHITE

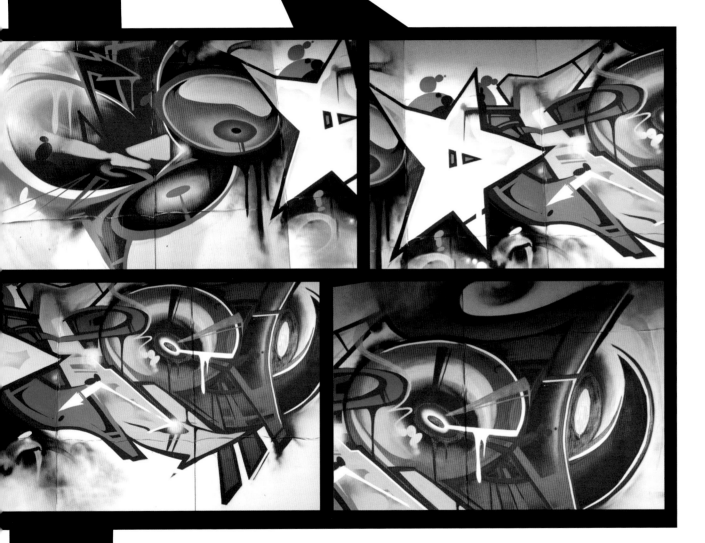

1 Drop in white throughout the work according to the light source, which in this instance is on the right. Dealing with white is the opposite of black; you can use it very liberally. Add details, drips and flare effects throughout the work to contrast opposing colors. Add in very thin lines of white to contrast the chunky outlines and make your colors scream.

SCAPE'S WORDS OF WISDOM

The *human factor* is the human component of your art. It is the identity you choose for yourself that reveals your humanity. The human factor is all about you and how you get down! We are human beings with souls, not robots. You don't want to get so lost in your art, whether street art or studio or someplace in between, that you lose your sense of self. Understanding this will give you the insight to create great work that can inspire and transform because there is a bit of ourselves in our art. Through color and design we can create art that resonates and connects us to our human side.

Four Ponderings of the Human Factor

Your Aesthetic: This is the search for and appreciation of beauty. Your aesthetic is coupled with your imagination and creativity.

What you gravitate toward—beautiful objects, colors and designs—and how they spur your imagination and creativity.

This can happen consciously and unconsciously.

Your Human Side: This is your skill sets and understanding of your tools, all coupled with your experiences, knowledge and intelligence.

Your Ability: This is your power and willingness to execute your ambitious ideas. Are you diligent? Do you have the courage to be unique?

Your Potential: This is recognizing and thinking about your talents, which you may not have shown yet, but that you plan to develop in the future.

How does it all fit together? The simple answer is that you are a human being, a human being who creates art and expresses it. Anything that you can do to understand and improve yourself will allow you to create better art and be that better artist. It is important to take steps to understand yourself in order to transform yourself. You must be willing to grow and improve your skills so the artwork you create can transform both public and private spaces.

Once you get to a place of understanding, you will create more than just a tag, you will create something important. It's all about your creative vision, your understanding that when you create, you transform your surroundings. If you are in your studio and create a work, when that work is placed and hung, it transforms that space. The same is true outdoors. When you drop your work in the public sphere, everything around it changes and it creates conversation.

WHEN YOU WORK AT UNDERSTANDING YOUR HUMAN SIDE, YOU ALLOW YOURSELF TO CREATE WORK THAT HAS MEANING AND THAT IS IMPORTANT.

STEP 5: COMPLETED PIECE

1 Review the finished work, then remove the five canvas sections from the wooden panel. You now have five square pieces, each 4 feet (1m) by 4 feet (1m). They are ready to hang as a series of work or spread out individually! Later you can choose to tag or sign each piece individually with a paint pain.

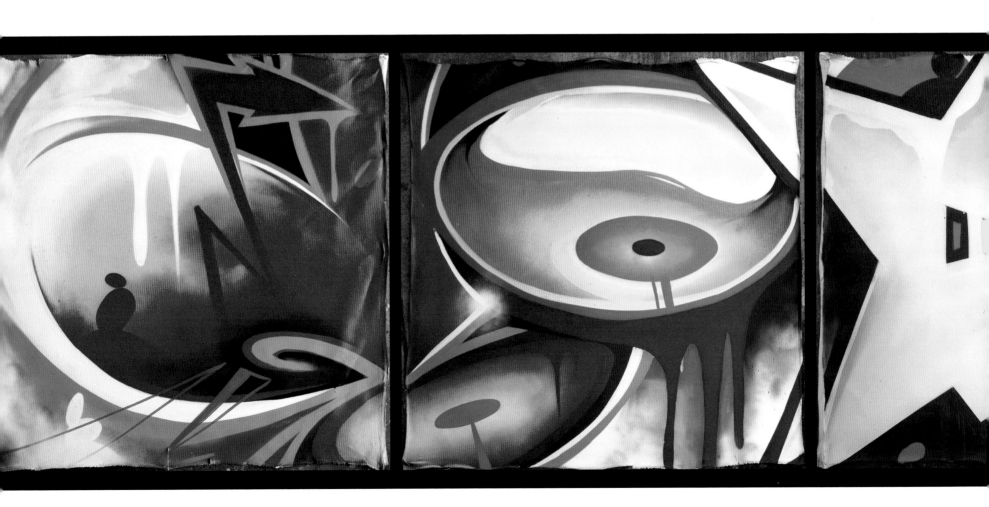

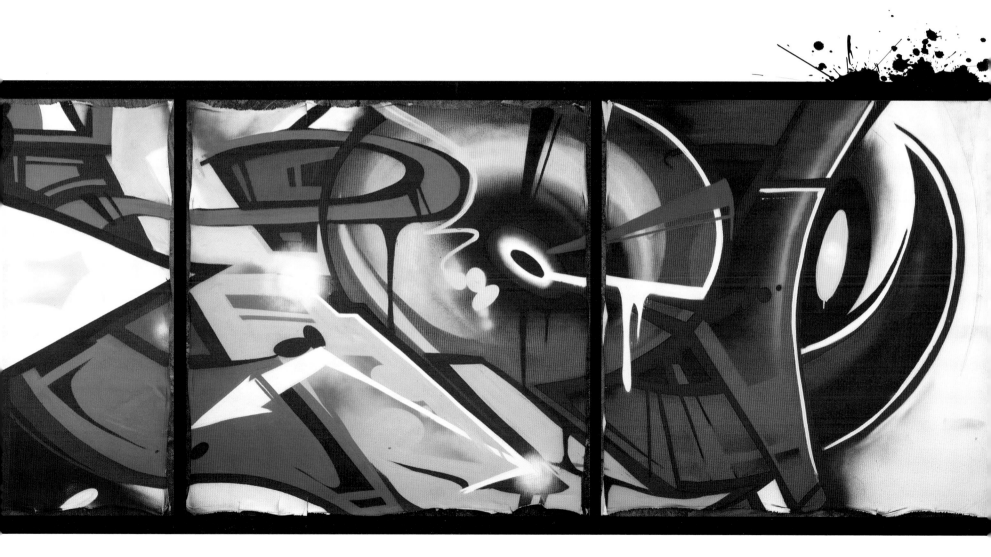

HTTP:
A Journey in Orange

Letterforms in your art can sometimes be limiting, so it's fun to explore a different way to get your message across. Over time, as I have dissected, altered and broken down the conventions of standard graffiti styles, I have found myself going after more raw and less structured creative spaces. With letters we focus on their fixed forms, so in this exercise we want to improvise and rely solely on our technique. Let go of the letterforms and embrace the color patterns and backgrounds. Bring them together to capture your voice and style.

We begin this process with orange. Orange is a very interesting color as it lives in the space between red and yellow. Most people either love it or hate it. To the naked eye, orange is a very hot color. Orange can combine the energy of red and the happiness of yellow. Orange possesses positive attributes such as creativity, enthusiasm and success. Orange is very bright and has high visibility. In your normal work it makes an excellent highlight color, but here it will be *the* color.

Our concept, **HTTP**, stands for *hypertext transfer protocol*. It is the foundation of connectivity for the World Wide Web; the four little letters at the beginning of a website address. So what does it have to do with us? Instead of focusing on a single word, we want to move in an abstract direction where we work with colors, movements and snippets of letters, connecting many small bits of information, just like **HTTP**. Using orange as our base, let's bring it all together!

SPRAY PAINT PALETTE
Our spray paints are carefully selected to work alongside the acrylics. They are mostly on the warm side of the color spectrum with a few cold colors mixed in for accents.

ACRYLICS PALETTE
Our acrylics palette is made up of passionate red, energetic yellow, festive pink and vibrant orange. These will be used for layering, glazing, color blends and various brushstrokes.

PAINTING TOOLS
Use a paint roller to lay down the orange base coat. We will also need a variety of wide brushes, glazing brushes and sponge brushes for glazing and blending in the early stages. My favorite tool for bold strokes is a 4-inch (100mm) flat brush.

STEP 1: FIRST LAYER OF WARM COLORED ACRYLICS

1 Our canvas is 8 feet (2m) high by 20 feet (6m) across. Cover the entire surface with orange using a roller and interior flat orange latex paint from the hardware store. This is a very large surface, so when it's buffed all orange, soak it in and recognize how it transforms the space.

2 Create a rich acrylic wash over the base orange. Start with pink and work it into yellow, then into the orange. Create your wash with both gel medium and plenty of water. I suggest 2 parts fluid acrylics, 1 part medium and 1 part water. Allow the color to drip and create movement. Your eye will follow the changes of color value.

3 Begin layering by rotating back and forth between the wash and bold, heavy brushstrokes. Movement is created by allowing the brush to do what it does. Have a battle with your brushstrokes; they should not all go in the same direction. Use a 4-inch (100mm) wide brush and bring in reds and pinks. Use your whole body when making your strokes to reach and stretch across that canvas. And remember to keep your brushes clean!

4 Walk away and look at it from a distance. Feel your way around the art. Ask yourself, *Does it move?* Notice all the colors crashing into each other and how in some areas they seem to float and in others they blend. If you need to add more color, do so. Strive for pure color and no muddy areas.

1 Add the next layer of color with spray paint. Do not paint completely over the previous step; instead add light shades of spray paint. Drop color into the in-between areas with some white, dark and light pink, yellow and turquoise. Add a few expressive lines and drips. Begin to drop in words and phrases. Tag it up and be bold!

2 Remember you have a large canvas, right? So take your time and recognize you are building a dialogue. The dialogue is with yourself, the wall and the audience who is going to see the work. Pace yourself, move left to right and start tapping into the tricks in your pocket. Think of your graffiti color fill-ins and ask yourself where you can drop some of those in. Drop in more tags and take risks!

3 Step back and observe. Within the layers of colors we have movements, and within those movements we have dots, drips, bubbles, tags, flare effects and slices. All of these elements need to work with each other. Change your spray can tips from skinny to super fat and experiment. Keep improvising and be inventive!

STEP 3: ADD A COOL LAYER OF ACRYLICS AND THE FOCAL POINT

1 Switch to a cool palette to help the previous layers pop and vibrate. Lay in bold strokes of light blue mixed with gel medium using a 2-inch (51mm) flat brush. Blend some of it out on the right but keep it painterly. Strive for a chunky blend.

2 Go over some of the spray painted dots and ovals with whites and blues. Attack the canvas with a smaller brush and red, purple and orange acrylics to sharpen them up. Continue adding textures and depth as you go along, rotating between mediums and tools.

3 Step back and view the entire canvas as one giant fill-in. Your eyes should dart throughout the work between the layers, movements and textures. Create a large red glow on the left edge of the painting that will be the focal point. See how the painted edge of the canvas continues onto the back panels? Keep pushing the color!

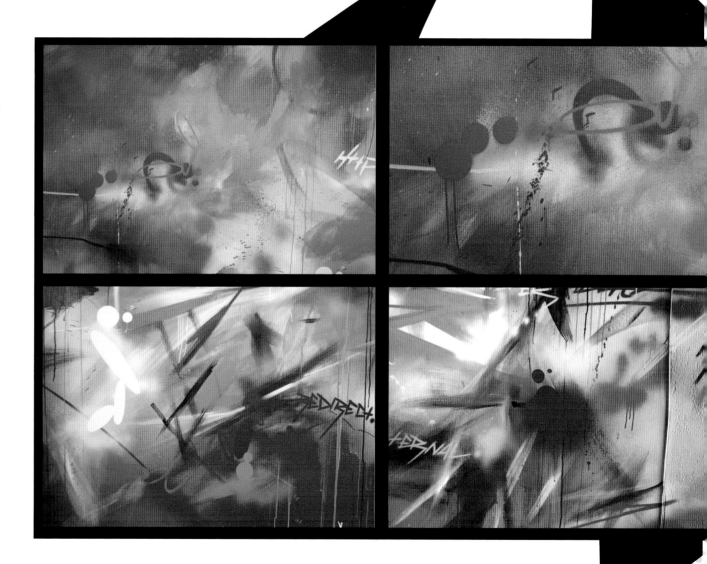

STEP 4: FINISHING DETAILS AND COMPLETED PIECE

1 Drop in any extra gestures and shapes that you think the piece needs. Work in layers and rotate between both acrylics and spray paint. Remember the initial ideas of being loose and expressive, using graffiti-styled fill-ins and abstract expressionist styles and flavors. Work the orange, yellow and pink as your middle layers. Keep a high level of contrast by flowing white and blue on top.

2 Finish up the style elements with black by adding a snippet of a letter or a slice of an outline. In many instances you can break the outlines of your letters to appear as simple bold lines. In this case this is a snippet of the letter **S**. Add some slices of blue for contrast, both in color and style. Use your graff-art sensibilities to continue sprinkling expressive bits throughout the piece.

3 Absorb the entire piece from a distance and snap some pics. Notice the textures and how the piece moves. Ponder how much freedom was involved in making it.

It can be challenging to create artwork that is not explicitly letterforms. Practice making art that enhances the visual experience without using a direct message. Work backward from your original idea, destroying the confines of letter structure along the way!

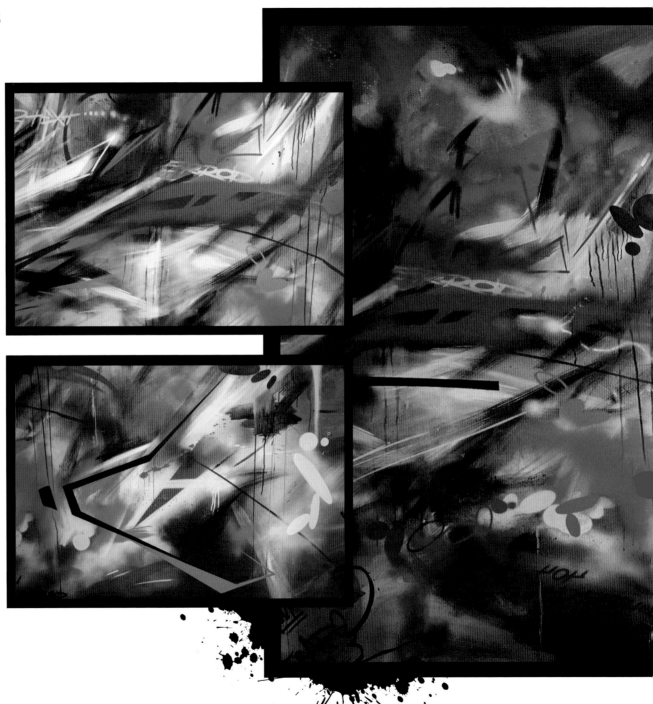

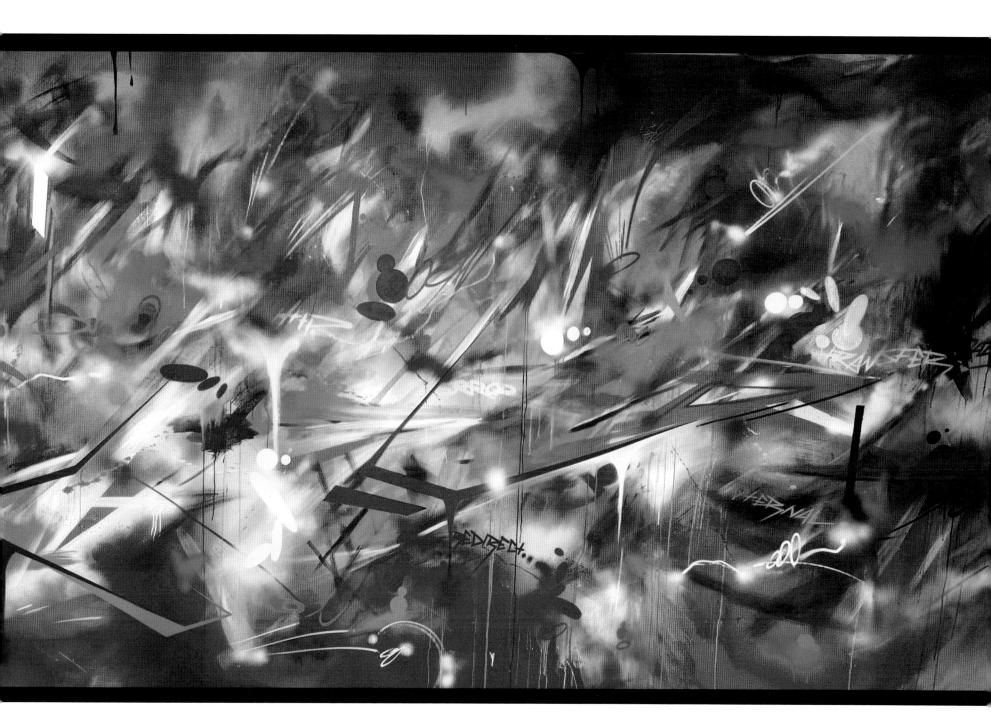

Some Kind of Blue

A *monochromatic color scheme* is made up of a variety of shades and tints of one hue. For an artwork made up of a variety of greens or a variety of reds, you would say monochromatic green or monochromatic red, respectively. You can create an infinite variety of shades and tints simply by adding black and white. Strive to include the following three principles when creating a monochromatic work: a strong juxtapositions and balance of hues, improvisational techniques and a good use of shadows and fades.

In this demonstration we'll work only within the base hue of blue from extremely light blue to extremely dark blue and everything in between. Blue is an intriguing color because it has uncanny depth and feel. It has many derivatives and meanings. Blue is a cool color, the coolest of colors, and carries many social and psychological properties. Blue is calming and serene and symbolizes solitude and peace. It's the color of the sky, the ocean and of twilight. The right choice of blue can make your subject pop right off the canvas. In this exercise we push the boundaries of blue to convey its expressive and emotive connotations. Open your mind and let's go!

HAVE A VISION
Someone will always say, "It can't be done." But that is only true until you go out and do it! You must have a vision for both yourself and your work. Aim to create art, not just a design or sketch or pattern. Create something that leaves a sense of place.

SPRAY PAINT PALETTE
Our palette is made up of a variety of blue spray cans from extreme light blue (near white) to very deep dark blue (near black), in various shades and tints. We will use no black or white in this piece, only blues!

ACRYLICS PALETTE
Select an array of blue acrylic paints and gel mediums. A water sprayer is also helpful for diluting heavy-bodied paints. We supplement the piece with acrylics to build texture.

BLUE BASECOAT
Select a cool medium blue as the base color to make it easy to go lighter or darker as you gauge your values for fill-ins and outlines.

STEP 1: PREPARE THE CANVAS AND BEGIN THE BACKGROUND

1 Loosely sketch your letter pattern—the word **BLUES**—keeping it open and unconventional. Emphasize the nuances of the letters with shadows and embellishments where they twist, fold and bend.

2 Prepare a large, heavy-toothed cotton canvas 7 feet (2m) high by 21 feet (6m) wide with a luscious, cool-blue acrylic base coat using a paint roller.

3 Work from dark to light to build the atmosphere of the piece. Apply the colors in layers so they intermingle and allow the blue primer to peek through.

4 Using light blues and white, begin making bold strokes using your whole body. Throw your whole torso into it, and create wide strokes and movements that will attract the eye and slice into the atmosphere. Also add some expressive details and purposeful drips.

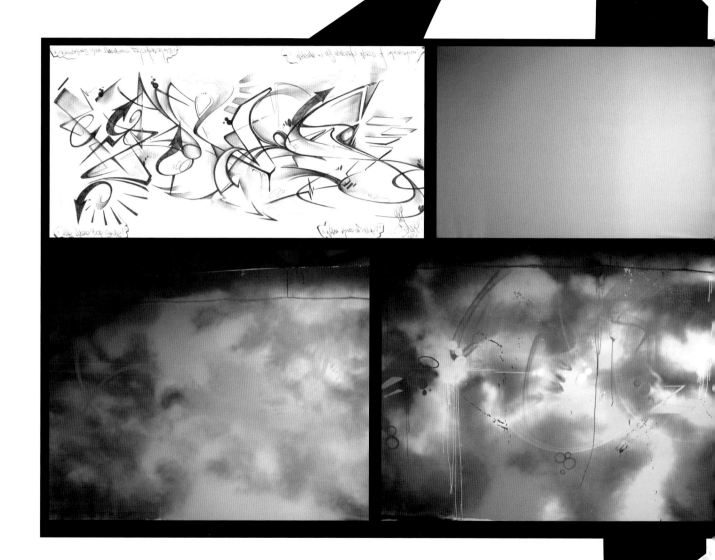

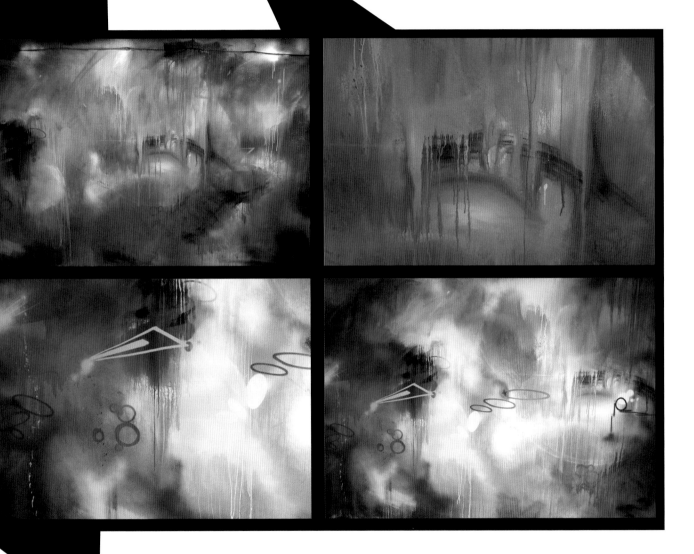

1 Water down your acrylics with gel medium and water, and let them run to create interesting details and textures. You want them to be transparent yet retain their blue hue. Rotate back and forth between spray paints and acrylics. In a random fashion throughout, place light blue spray paints around the deeper acrylic hues.

2 Work from light to dark, letting the colors run through the darker blues. Fluctuate from light to dark to dark to light. This step can get rather messy. Use your water sprayer to drench the wall with water to get the paint to run. Remember the qualities of acrylics. You can dilute and thin them with water and mix gel medium into the paint before you approach the wall. The amount of water you add is your personal choice depending on how you feel the paint is flowing.

3 Back away and look at the composition you've created. You should have a mash-up of spray paint, acrylics, drips, atmospheric effects, spray painted dots, bubbles and expressions. We are building the piece from the inside out by preparing an expressive background on which to place our message.

STEP 3: DROP IN THE LETTERFORMS

1 In the spirit of working backward, we drop in the last letter **S**. This is the only outline, so make it work. Use a blue spray paint that is very deep and dark. Use your sketch as a reference but improvise as you execute.

2 Begin your fill-ins in an improvisational fashion so you can make changes as you go along. Drop in the top part of the **E** and add some fade effects with a very light blue. Create an arrow that explodes outward from inside the **S**. Make an effort to keep your drips and textures exposed. Add to the mix without covering it all up.

3 Pick a midnight blue that is unique to the other letterforms and drop in the **U**. Each blue should work well next to the letters that come before and after.

4 Drop in the **L** with a true blue. Using a mix of blues from the previous letters, push some of your fills-ins from one letter into another. Make your outlines drip, roll, twist, enter and exit each other. Treat your outlines as fills, and treat your fills as if they were outlines. Have fun and break the rules!

5 Review your sketch before dropping in the **B**. Seek balance as you cut into the piece to drop the letter in. Use a very light blue to add a few tags, messages, glows, shines and aftereffects. Back up and critique your work and continue steadily to the finish.

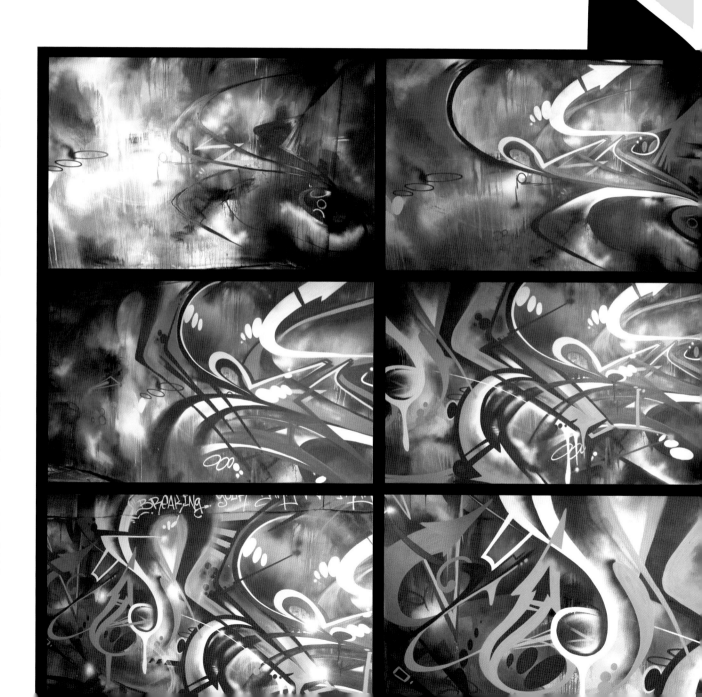

STEP 4: COMPLETED PIECE AND DETAILS

1 Drop in your final commentary and details—voilà! Remove your mask and exhale. There are many ways to execute monochromatic work; in this style, we focused on mixing and blending acrylics and spray paint. Revel in your success to creating a piece without a drop of white or black!

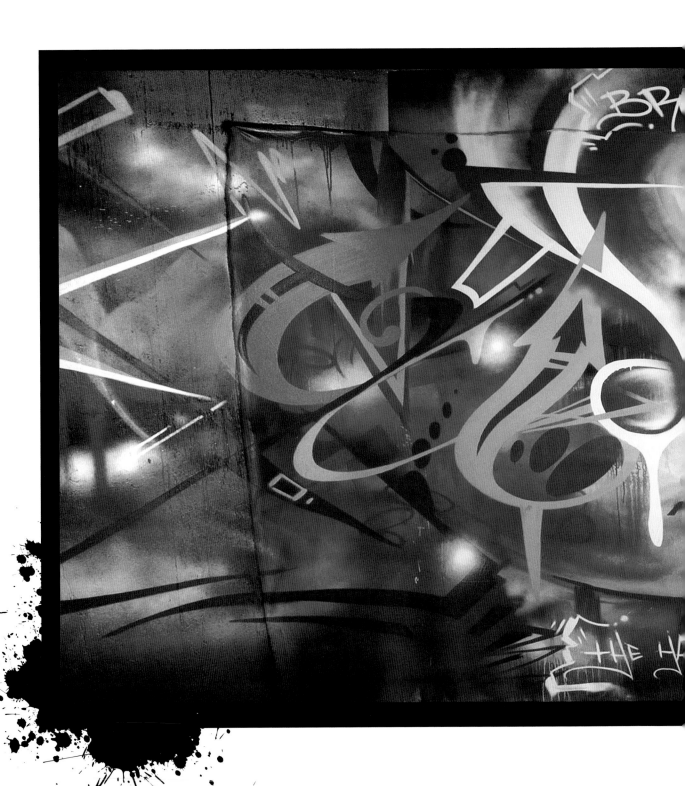

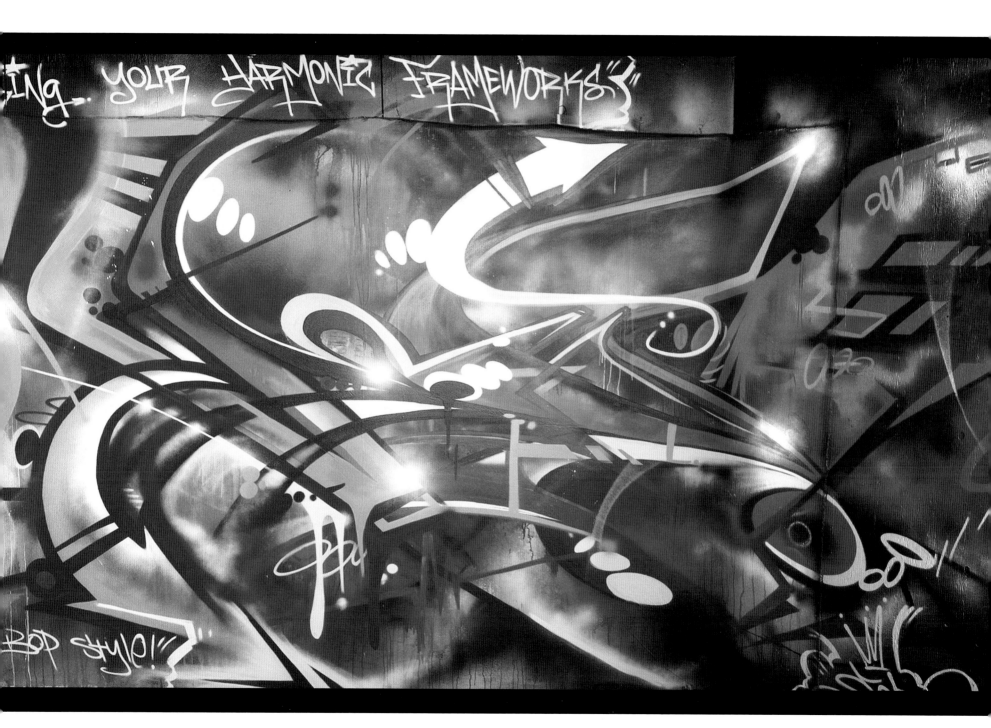

Supernatural Mystic

What is mysterious? What is arcane? When we as artists tap into our subconscious, what bubbles up seems at first mysterious. We don't understand it, yet it tends to work for us from a visual point of view. So how do you create something that's a bit mysterious? By planning out your palette and planning out your head space. What part of your mind do you want to explore?

In this demo, I chose to use black as a base color because black has a lot of meaning and symbolism. I like the idea of using it as the foundation of a piece rather than as a "throw-away color" as I've seen it used before. Black tends to hold bleak connotations, so here we explore bringing it life and energy.

Think of this demo as a color challenge: building high contrast on a flat black background. It's easy to create from an emotional point of view if you are full of rebellious and intense energy. This is a very natural creative leap. This is also a great opportunity to create some work that is very close and personal to you. For an abstract styled piece like this, it is very important that you look at expression over letter draftsmanship and work toward the unknown over the known. Going for the inside of this thing versus the outside of this thing. Paint what you don't know!

In this demonstration, we blur the line between canvas and wall. Instead of trying to cram as much visual information on a canvas as you'd put up on a wall, we split the surface into multiple canvases. By applying the black basecoat to the entire painting surface and wall support, we can create as large as our vision intends. In this demonstration we spell out **MYSTIC**—six letters spread across five panels. Starting with a black base, it's all about layers upon layers to make your point of view pop!

MASTER YOUR TECHNIQUES

Practice your color patterns and fading techniques. You want your coloring techniques to be as intuitive as possible. By doing so, your work will be a bit more authentic and painterly and less cookie-cutter and static.

FULL PALETTE
Our palette is heavy on the hot and warm colors—pinks, reds, oranges, purples—with a little green, very light blue and limited white. Choose colors with dark values to help them pull from the black background.

CANVAS
Staple 5 canvas panels to your wood panel background. Three are positioned squarely in the center of their panels, and 2 are tilted askew to create a unique composition.

BLACK BASECOAT
There are many different shades of black. Lightly layer aerosol black over the basecoat, letting it drip where you see fit to build texture.

STEP 1: ADD STAR EFFECTS WITH HOT COLORS

1 Splash and drip some of your hottest colors across the surface of the canvas. At this stage you want to create light spray effects; you are not yet building layers. Let your intuition guide you throughout the canvas.

2 Work from dark to light with a spectrum of blues (dark, medium, light) to create starry special effects that bleed into white. The white should simply be a splash of color on top.

3 Create more astral effects as in step 2 with a variety of other color spectrums. Begin with a deep burgundy, then work your way to red, orange, yellow and a splash of white. Add these elements in a very random, nonlinear fashion. Do not focus solely on the canvas but fill in all the nooks and in-between spaces of the back panels; see the entirety of the work space.

4 Connect the colorful star effects with thin trails of spray paint using the color of the effect the most prominently registers with the eye.

1 Drop in some expressive lines with the darkest value of each star effect's color. Don't overdo it; you want to add flavor, not confusion.

2 Back up and observe. Continue to make connections between the elements with expressive lines, arrows and other expressive elements. Add dots, bubbles and swirls until your eye dances across the canvas. Reach for the black again and experiment with black highlights and clouds. A color shine is a blurred-out splash of color. When done with white it looks like a star on a dark background. Try producing shines with different colors, in this case, black. Our goal is to increase the richness and depth in the work by creating layers and layers of colors and design elements.

3 In this close-up, notice how your eye focuses on the white shine to the right, but also the red lines to the left. The lines are segments faded out with quick strokes of the spray can. Elements like this keep your eye moving across the page.

STEP 3: CONTINUE ADDING DETAILS AND DROP IN THE LETTERFORMS

1 Switch to a skinny cap to add thin stress lines and accents to create tension within the piece. Continue to create slices of color and more layers, staying judicious with your placement.

2 Add more clouds, bubbles and fades with black to create a misty sense of mystery. At this point you should see an infinite number of layers and illusions of colors, space and techniques. Your colors should not be muddy or in conflict. There should be a flow to them, your eye bouncing from one to another.

3 Begin to drop the letters in, working backward from the **C**. Use a very light blue so it stands out and away from the previous layers. Drop the forms freestyle with no sketch, keeping them open with no outlines.

4 Move through your letters until you get to the **M**. Try to just leave hints of the letters instead of thinking of them in a truly literal fashion. Work in the negative space of the letters and try to be consistent in your approach as you go along.

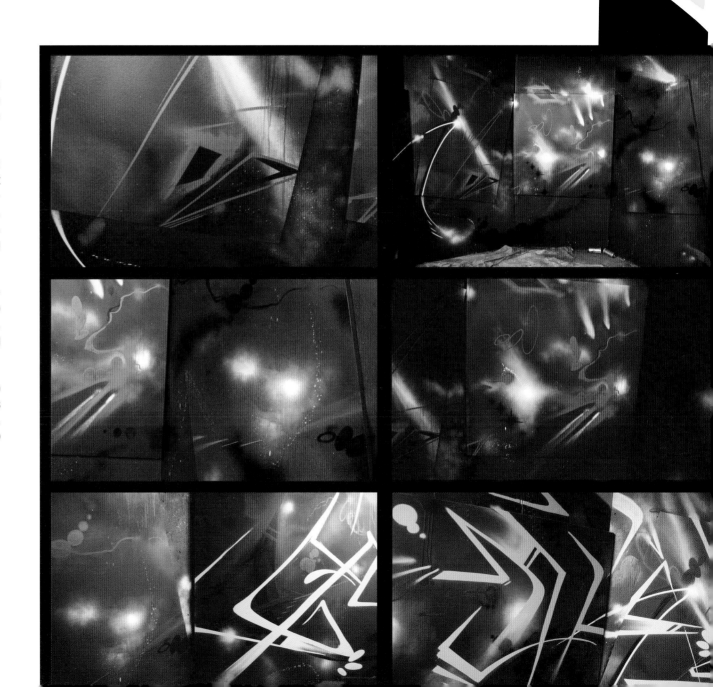

STEP 4: ADD THE FINAL DETAILS

1 Once your letters are dropped in, add some final expressive arrows and swirls with pure yellow and hot reds. Apply pure white in a bold and chunky manner to add to the strong contrast of the yellow and red. Use these colors as a sort of fill-in style element, rather than simple highlights, to balance out your forms. Keep working it until you get to that magic breaking point where you can just drop the can!

2 Scan the whole surface of the work and make sure all the elements are in place. Does it get your message across? Add your tag to the work, step back and exhale!

STEP 5: INDIVIDUAL CANVASES

1 Here are the 5 panels side by side, removed from the back wall. Trim away the excess and we are left with 5 unique compositions! Each slice retains all of the energy and mystery of the whole work. Enjoy!

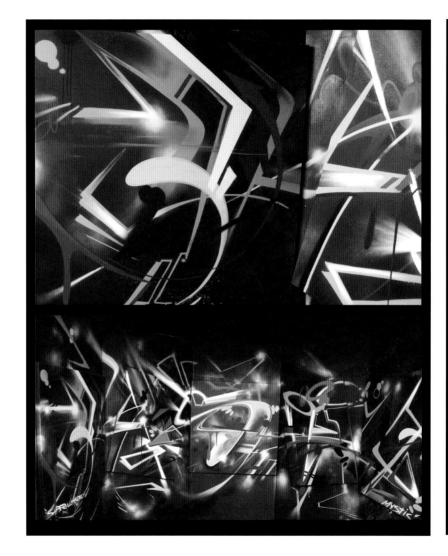

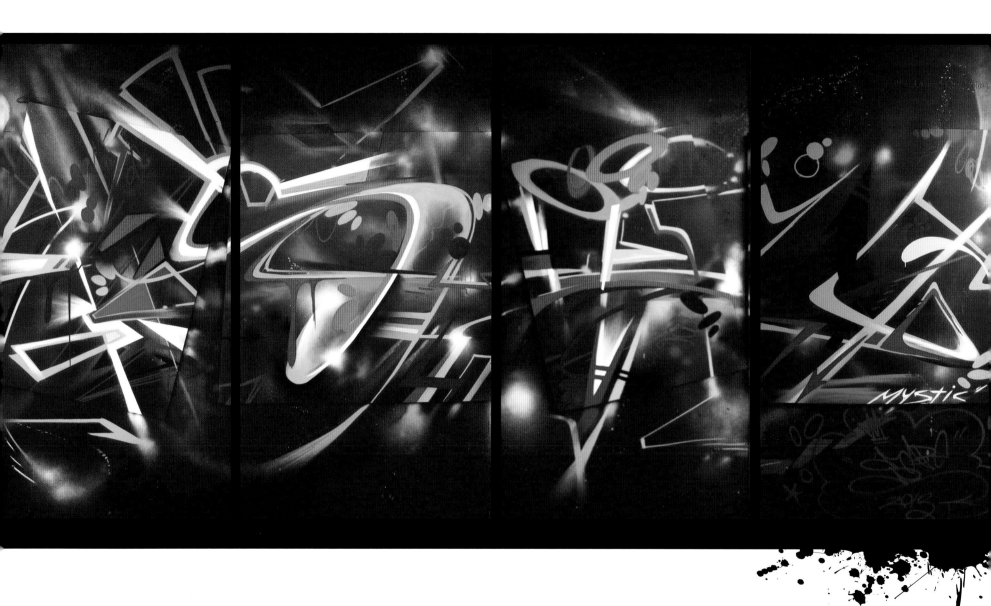

A Love Supreme

Let's explore the idea of working freestyle without a sketch. Like a jazz musician or an emcee, we must create from memory, pairing up what is recorded in our brains with our intuitive processes. Discard from your mind all the letter styles and color schemes you've practiced, and work totally in the present.

In this exercise our freestyle concept is all about movement and energy, recollection and disruption, making the colors dance, making the letters move. It is not about memorizing flows; it is about reaching for something new. How much energy and passion can you put on display in one piece? How can you create a snapshot of your imagination, a visual record of what goes on inside of you? Use your intuitive understanding and command of color and letter structure, and paint from that unknown place within you.

Here we work on canvas and float between acrylic paints and spray paint. Try to effortlessly move from brushstrokes to spray can effects, from glazing to cutting, from controlled splatters to unrestrained action painting. Be mindful of your hands and how you feel, how your hands curl around the spray can or your fist-like grip when holding a flat brush. Notice the viscosity of the acrylics and how the spray paint floats out of the can. Ponder these things before you even begin. Last step first, first step last, but put your imagination up front and let's work freestyle!

PALETTE
Our spray paint palette is heavy on white, pink, red and purple with few cool colors used as accents such as blues and greens and, of course, black. Our acrylics are CMYK-based.

CANVAS
Our canvas is a heavyweight cotton duck with a heavy tooth. It is first primed with white gesso, but also buffed with interior flat latex paint in blue, green, teal and pink. The pattern created is haphazard and random, which will be the base of our collage of colors.

STEP 1: PREPARE THE BACKGROUND WITH ACRYLICS AND SPRAY PAINTS

1 Begin by adding basic gestures of acrylics using a flat brush and cyan, magenta, yellow, black and white. Be confident and deliberate. Focus more on juxtaposing the colors and less on blending. If the paint drips, let it! Just don't let the colors merge too much to become muddy and lose their properties.

2 Add purposeful drips, paint splatters and expressive lines with spray paint. These colors are from the original spray paint palette. Match any acrylics you use to your spray paint palette; for instance, if you use a yellow spray paint, try to use a similar yellow acrylic. Remember, you are operating outside the box—do not think of form or function, only the interplay of colors and their emotive properties.

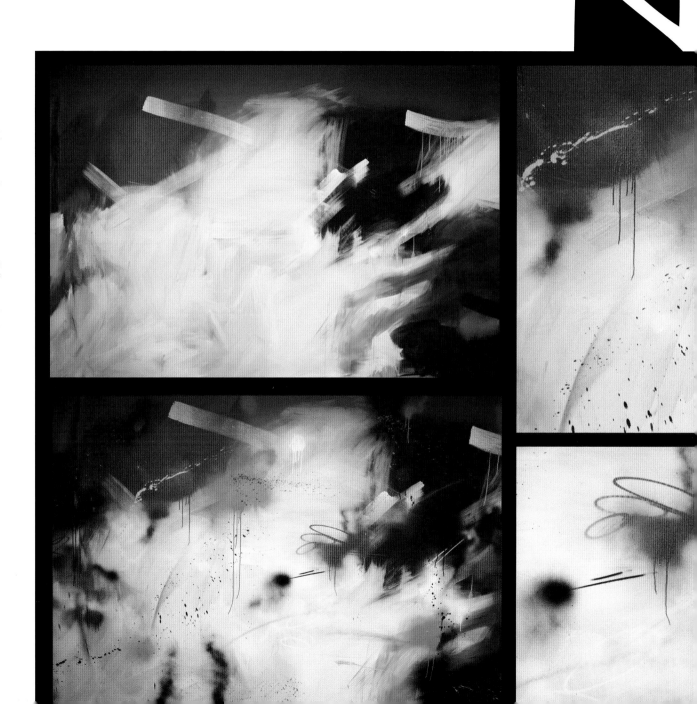

STEP 2: ADD MORE DETAILS AND EXPRESSIONS

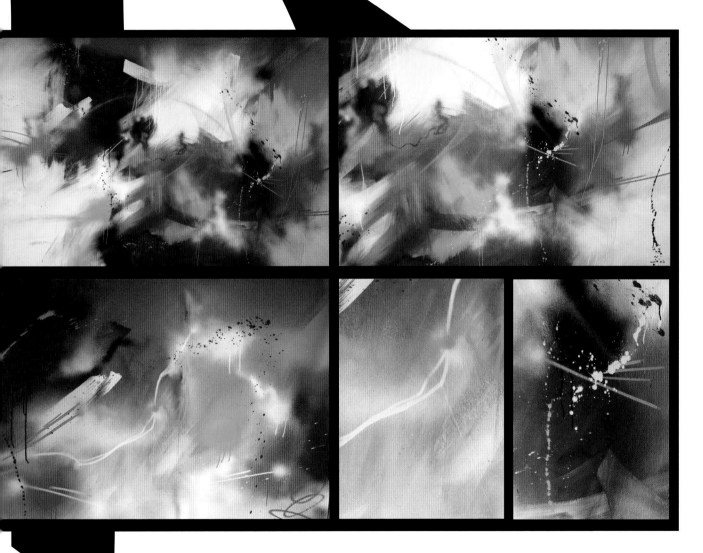

1 Rotate back and forth between skinny caps and super fat caps to build up layers of colors and marks. Work through your color palette and be as expressive and as visually interesting as you possibly can. Think less and feel more.

2 Step back and make some observations. Are you creating movement and tension within the composition? Does your eye meander throughout the work? Does it fall in certain places and want to stay there? If so, revisit certain areas and continue the rhythm.

3 What colors can you add to create more energetic layers? Streaks, splatters, drips or blurred lines? Why not all of them? Experiment with organic shapes, ovals and outlines of forms to build up the textures within the piece.

STEP 3: RENDER ACRYLIC GLAZES AND ADD MORE DETAILS

1 Create an acrylic wash over various areas of the piece with a translucent color such as yellow. Rotate back and forth between paintbrush and spray can creating glazes and drips.

2 In this close-up you can see all aspects of the layers: the basecoat, the spray paint floating on top, the acrylic drips and glazing, and expressive lines and spray paint drips.

3 From the formation and textures you've created, begin to extract or pull shapes, arrows, bubbles and dots to interplay with the colors. In the hot pink area, go over that with bright pink spray paint, matching close to the acrylic hue, creating arrows that emerge from the pink space into other areas. Go back in with yellow spray paint and cut a pink arrow out, and fade yellow back into the background. Make your marks very close to the canvas and keep your movements tight and crisp. Black arrows shoot out from the black, and magenta arrows shoot into the red and yellow. Look all across the piece and find places that command attention; keep your eyes and hands going for technique. Can control is crucial at this stage.

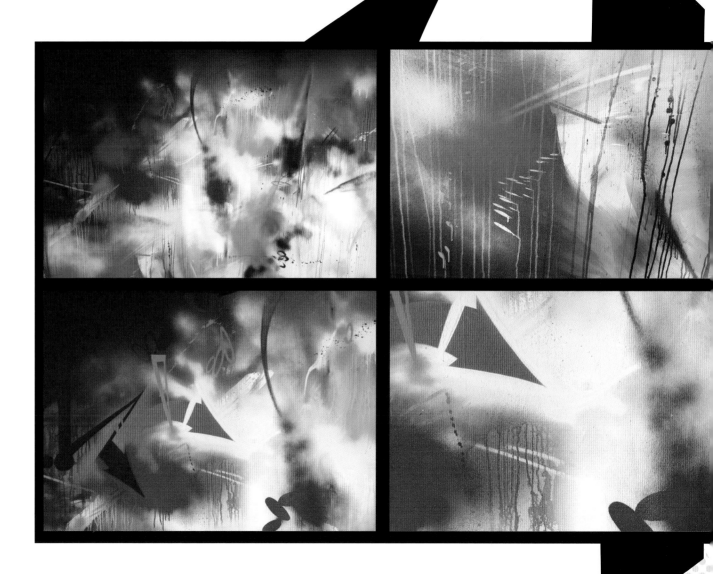

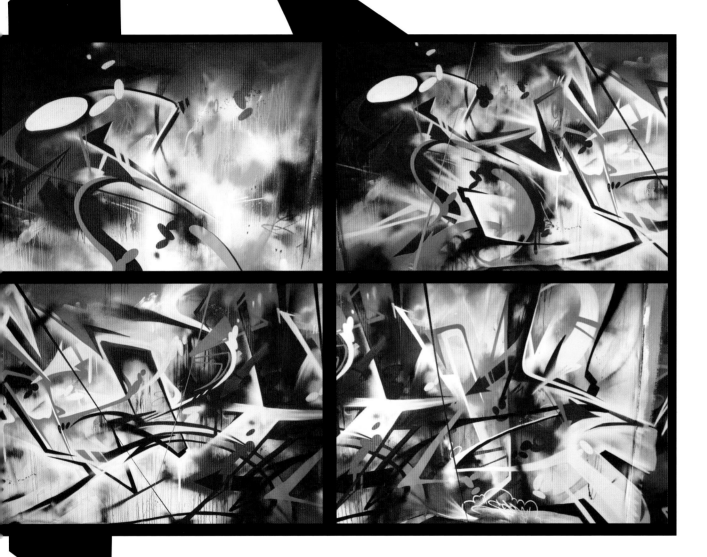

1 Drop in the outline of the **S** with black, the first letter of our concept, **SUPREME**. Keep your letters hollow and transparent, and your approach minimal.

2 Take creative license with your letters and change the color of the outlines for each letter. The lower part of the **S** is blue and purple, while the **U** is a simple black hook shape and the **P** is rendered in a blue outline. As you move forward, add additional accents and graphic effects.

3 Break up the letters by form and by color while maintaining their transparent properties. Add colors from one letter into the next.

4 Moving along, drop in the **R, E, M** and final **E**, each letter a different color. Work only with the outlines first, then add colors and accents making sure the colors flow. Your forms should twist, turn, overlap, undulate and in the end build a rhythm.

STEP 5: DETAIL SHOTS

1 This detail shot is a great example of the layers at work. You want to be able to look at the work up close and see what's underneath. The depth is created because your eye registers all the layers. Notice how the magenta and turquoise lines sit on top and push forward over the drips and wash. The more layers, the more depth, the more interesting.

2 In an artwork you sometimes have certain areas where everything falls into place in exactly the right way. The colors, movement, mood, structure—everything resonates. I call this "the sweet spot" of the piece, shown here in this detail shot.

3 This is a total action shot. Can you feel the movement in the art? Note how the colors overlap with the others. Arrows go over and under, and dots lie on top and below. It's all about depth.

4 From this point of view, note the vortex-like shapes and tension and imploding letter elements. You can think of a vortex as your paint swirling, pulling, ebbing and flowing in a loose, circular manner. White intuitively brings light into the piece and is used in the structure of the letterforms. Conversely, black invites a shadow effect.

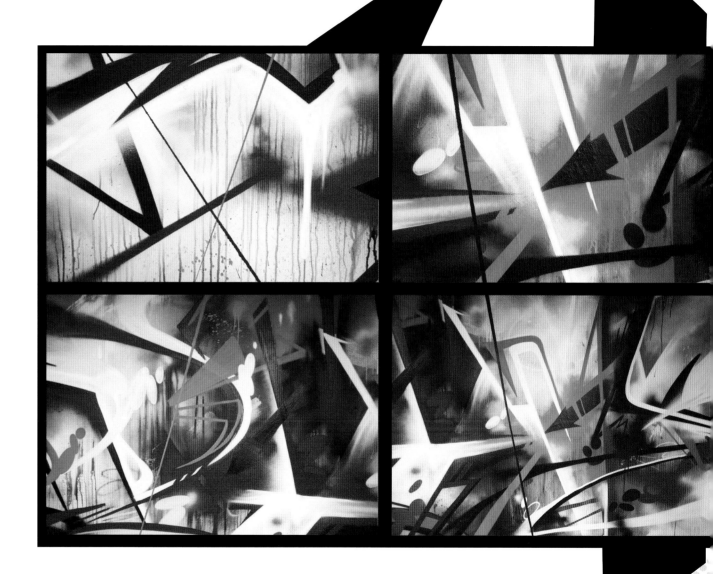

STEP 6: COMPLETED PIECE AND DETAILS

1 Our masterpiece is complete! Walk back and absorb it, take it all in. Notice all the pieces working together. There shouldn't be any areas that override or take away from others, only rhythm and balance throughout the entire composition. This type of graffiti art is based on expression and abstract thinking. It is not designed to be replicated, so the only way to duplicate it is by photograph. Enjoy!

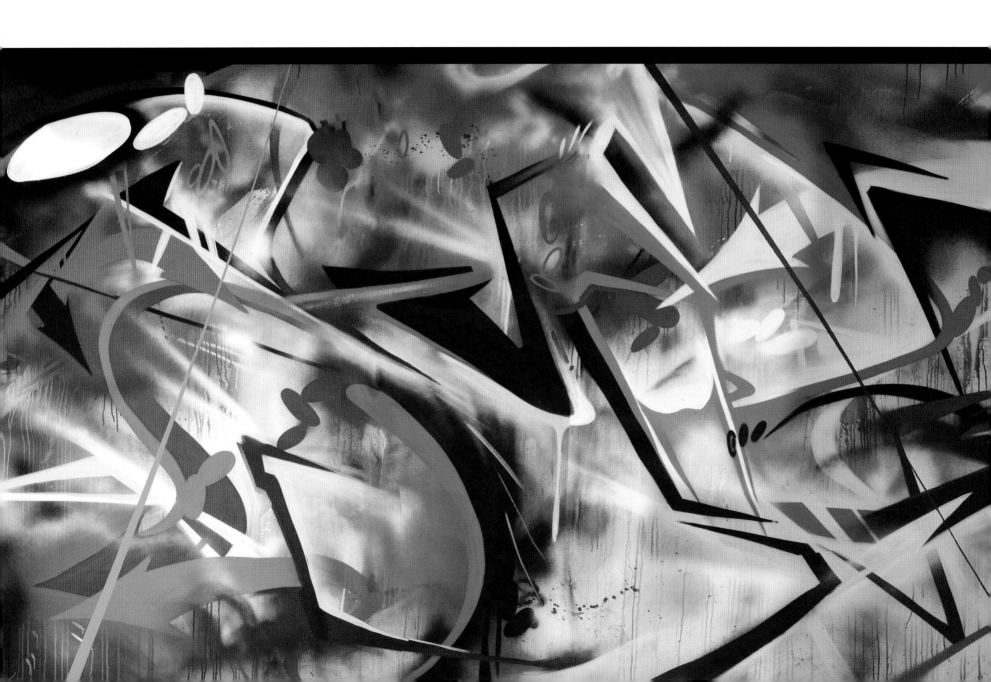

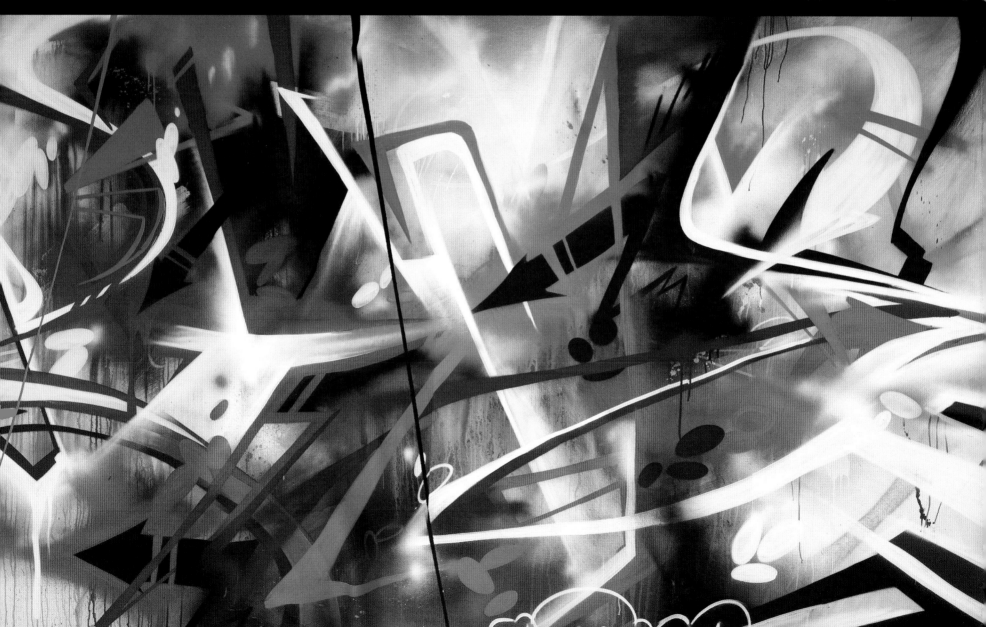

Conclusion

My hope is that this isn't the end but just the end of the beginning. That moving forward, this book will be a stepping stone for you to explore color in your work and in your life and create even bigger and better pieces than what you have experienced before.

Color brings beauty, meaning and life to works of graffiti art, street art and urban art worldwide. In our natural environment, since the beginning of time, color has had the same purpose. Color is the most valuable and interesting of all the elements of art and design. Color is the central element for your graffiti/street art styles, and it makes all your work attractive and noticeable.

So how valuable is color? Color can change how you think, it can stop you in traffic, distract you when walking, cause a chain reaction in your mind, stir the synapses in your brain to send you into a sensational tailspin when you see that perfect piece of art. That is the power of color.

Color can soothe you, put you to sleep, wake you up, raise your blood pressure, excite you, teach you, upset you, confuse you, make you run away. Color can disturb you and shock you. Color communicates because **color is powerful, and powerful color is more powerful still.**

So when it comes to color, some people fear it because they don't understand it; some people love it because they feel it, but no one is indifferent to it. Color is going to be the main vehicle you use to make hot visual statements to push your art out into the world.

My hope is to have shared how I use it and give you ideas about how you can use it as well.

The Infinite Art, Colors Are Infinite!

Combine your color schemes, letter styles, emotional reactions and perceptions, locations and context. Out of all of these, color will be the standout element!

Color is the most important element of art, so much so that at times it can become the sole element of your art. It can be your subject, your form, taking shape. It is, in short, your everything!

In the end, as much as we can discuss color, study it, flip it on its head, look at color wheels and charts, for me color is about feeling it, experiencing it. Experience color in all its myriad ways and internalize it all; get in tune with it so it becomes intuitive. So when you are creating your work, you can connect your choices of colors in an improvisational and meaningful way, making your work very personal and effective. And when it works well, you really cannot explain it because in the end it becomes that inexact science. What works today may not work tomorrow, may not work next year. But eventually all of this working channels into meaning.

And as much as we look at how color has meaning, it is most important to know what color means to you! There truthfully is no right or wrong way to use color; there are simply better ways or more effective ways. So couple all the knowledge acquired about color usage with your art-making techniques and creative aspirations. Understand that now it is about the art of graffiti and not about the act of graffiti, and when you get to that level and embody that idea, watch as the world opens. Your art can now go anywhere.

Whereas before you were solely concerned about concrete walls, now there are infinite walls. Prepare yourself with an understanding of infinite colors, and begin your walk to color the world with your infinite styles and create your infinite art!

It's less about what it says and more about what it SCREAMS! That is the power of color.

—Scape Martinez

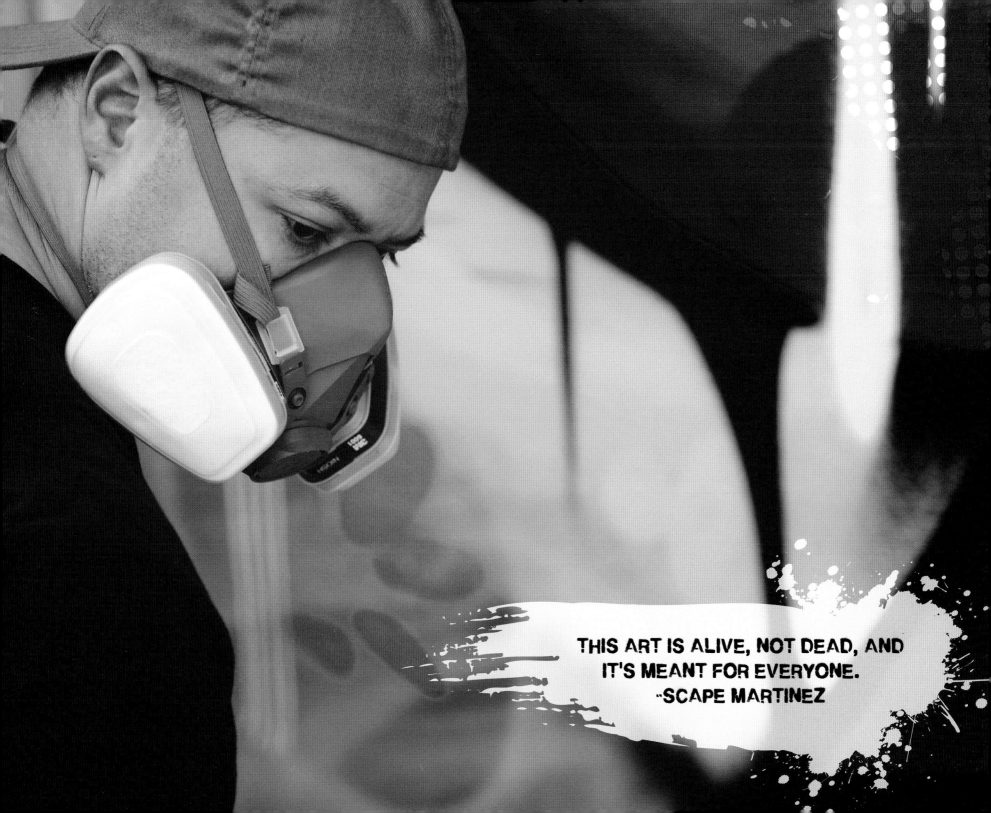

THIS ART IS ALIVE, NOT DEAD, AND IT'S MEANT FOR EVERYONE.
—SCAPE MARTINEZ

Index

fw media Other fine IMPACT Books are available from your favorite bookstore, art supply store or online supplier. Visit our website at fwmedia.com.

17 16 15 14 13 5 4 3 2 1

DISTRIBUTED IN CANADA BY FRASER DIRECT
100 Armstrong Avenue
Georgetown, ON, Canada L7G 5S4
Tel: (905) 877-4411

DISTRIBUTED IN THE U.K. AND EUROPE
BY F&W MEDIA INTERNATIONAL LTD
Brunel House, Forde Close, Newton Abbot, TQ12 4PU, UK
Tel: (+44) 1626 323200, Fax: (+44) 1626 323319
Email: enquiries@fwmedia.com

DISTRIBUTED IN AUSTRALIA BY CAPRICORN LINK
P.O. Box 704, S. Windsor NSW, 2756 Australia
Tel: (02) 4560 1600; Fax: (02) 4577 5288
Email: books@capricornlink.com.au

Edited by Sarah Laichas
Designed by Brianna Scharstein
Production coordinated by Mark Griffin

978-1-4403-2829-9

METRIC CONVERSION CHART

CONVERT	TO	MULTIPLY BY
Inches	Centimeters	2.54
Centimeters	Inches	0.4
Feet	Centimeters	30.5
Centimeters	Feet	0.03
Yards	Meters	0.9
Meters	Yards	1.1

about the author

Born in Newark, New Jersey, and now living in San Jose, California, Scape Martinez has been creating art since childhood. He fell in love with graffiti art in his early teens. He authored the bestselling *GRAFF: The Art & Technique of Graffiti* (2009) and *GRAFF 2: Next Level Graffiti Techniques* (2011) detailing the styles and techniques of the often misunderstood art form. Scape has a remarkable gift for illustrating and articulating abstract thoughts and issues, and he frequently gives educational lectures on creativity and graffiti art's place in society. He has done public art projects for the city of San Jose, created murals for various schools and universities, and frequently shows his artwork in many galleries and settings. Scape continues to push the boundaries of graffiti art as well as his own unique form of artistic expression. You can visit his website at scapemartinez.com.

Photographed by Vanessa Solari Espinoza

acknowledgments

There are a number of wonderful people who contributed to my building, imagining, writing and executing this book. Thank you to Pam Wissman, you saw something in me that I didn't see in myself. You plucked me out of the mire and look now, we made some history, so many thanks! Thank you to everyone at F+W and the IMPACT staff. You continue to treat my work with great dignity and respect. Thank you to all the Mural Music & Arts Project staff, thank you all for your patience and encouragement, which meant the world when things got tight. Thank you to Sonya Clark-Herrera, your tireless leadership and encouragement over the years has pushed me forward in innumerable ways. Thank you to Olatunde Sobomehin, your approach to community and youth development always leaves me motivated. Thank you for your generosity and enthusiasm. I learned from you in countless ways, thank you to Jeffery Camarillo, your passion for teaching and working with youth has always inspired me to step up. Thank you for your contribution and the blessing you gave to this project. Thank you to Ryan Derfler and Cityteam for your blessings and enthusiasm; we planted a great seed, and thanks for saving me from getting arrested. Thank you to Vanessa Solari Espinoza, your talent and creativity know no bounds; you worked tirelessly to enhance this project with your vision and energy. You helped make this book happen, and you continue to inspire me and countless others. Thank you to Kenneth Love, who helped me be the person I needed to be, when I needed to be. You helped me recognize my talents and bring my vision to life, thank you for your mentoring and all your insights. Thank you to Myra Colon, you gave tirelessly and never gave up; you pushed when others quit. Thank you for steering me and keeping me focused, this book couldn't happen if I couldn't happen, and you made sure that I saw my future, many thanks to you.

DEDICATION: I dedicate this book to the memory of my father, Jose Martinez. May you rest, I will see you again.